IMAGES
of America

HISTORIC
OAKLAND CEMETERY

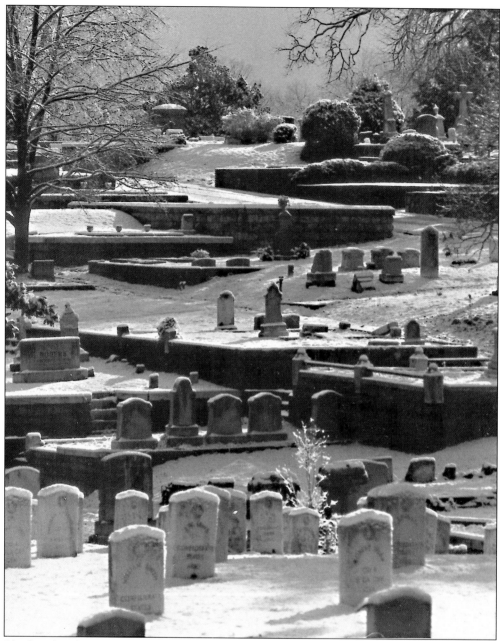

Blanketed with a rare dusting of snow, this view of Oakland demonstrates the rolling hills of the cemetery. Now seemingly dwarfed by the nearby skyscrapers of downtown, Historic Oakland Cemetery is actually sited on one of the highest ridges in Atlanta. Shown is the cemetery's southeastern quadrant, including Section E of the Confederate Section. Retaining walls allow for family plots amongst the hills. Constructed mainly of brick in the early 1900s, paved pathways and roadways allow access throughout the grounds. More than 70,000 people have been buried at Oakland in the last 150 years. Today, the cemetery hosts an average of two funerals per month. (Photo by R. Shane Garner.)

IMAGES
of America

HISTORIC
OAKLAND CEMETERY

Tevi Taliaferro

ARCADIA
PUBLISHING

Published by Arcadia Publishing
Charleston, South Carolina

Printed in the United States of America

Library of Congress Catalog Card Number: 2001089139

For all general information contact Arcadia Publishing at:
Telephone 843-853-2070
Fax 843-853-0044
E-Mail sales@arcadiapublishing.com
For customer service and orders:
Toll-Free 1-888-313-2665

Visit us on the Internet at www.arcadiapublishing.com

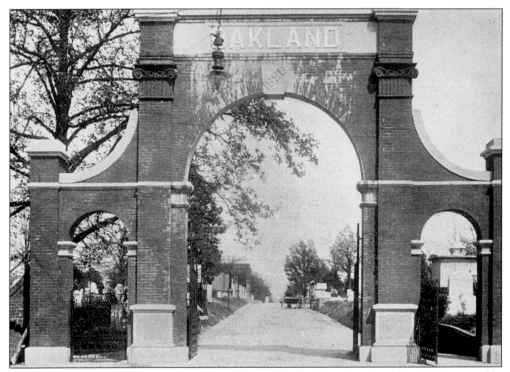

According to written correspondence from Atlanta's late historian, Franklin M. Garrett, this photograph of the Hunter Street Gate was taken between 1900 and 1910. Hunter Street has since been renamed in honor of Dr. Martin Luther King Jr. With the keystone dated 1896, this "new" gate currently serves as the cemetery's main entrance, at the corner of Oakland Avenue and Martin Luther King Jr. Drive.

returnable only to the retailer or seller from which they are purchased, pursuant to such retailer's or seller's return policy. Magazines, newspapers, eBooks, digital downloads, and used books are not returnable or exchangeable. Defective NOOKs may be exchanged at the store in accordance with the applicable warranty.

Returns or exchanges will not be permitted (i) after 14 days or without receipt or (ii) for product not carried by Barnes & Noble or Barnes & Noble.com.

Policy on receipt may appear in two sections.

Return Policy

With a sales receipt or Barnes & Noble.com packing slip, a full refund in the original form of payment will be issued from any Barnes & Noble Booksellers store for returns of undamaged NOOKs, new and unread books, and unopened and undamaged music CDs, DVDs, vinyl records, toys/games and audio books made within 14 days of purchase from a

YOU MAY ALSO LIKE...

Atlanta Scenes (Images of America Seri...
by Atlanta History Center Staff; B...

Historic Grant Park, Georgia (Images o...
by Cuthbertson, Philip M.; Goad Cu...

Inman Park, Georgia (Images of America...
by Jones, Sharon Foster; Marr, Chr...

East Atlanta, Georgia (Images of Ameri...
by Bryant, Henry; VanCronkhite, Ka...

CONTENTS

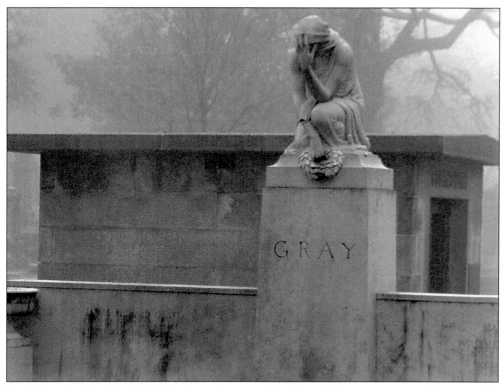

Symbolism is often found in Victorian-era cemeteries. One of the many outstanding examples of symbolism at Oakland Cemetery can be found at the Gray family plot (Block 36, Lot 2). This beautiful marker features a statue of the mythical Niobe, who was turned to stone as she wept for the deaths of her 14 children. According to the myth, the children were killed because Niobe loved them more than the jealous gods. (Photo by R. Shane Garner.)

ACKNOWLEDGMENTS

Many thanks to everyone who helped make this book possible, especially Mary Alice Alexander for giving me the chance to serve as preservation coordinator of this sacred and historic site. My gratitude also extends to Marla Bexley-Lovell, Sam Reed, Larry Upthegrove, D.L. Henderson, and Leigh Burns. The generosity of those who shared their photographs and information was overwhelming. My wish is that the legacy of Historic Oakland Cemetery will continue for another 150 years.

INTRODUCTION

An oasis of art, history, and green space within downtown Atlanta, Historic Oakland Cemetery is the city's oldest permanent landmark. Founded in 1850, Oakland Cemetery's 88 acres serve as the final resting place for more than 70,000 Atlantans. Not only is this special place a locally designated historic district by the City of Atlanta, but Oakland was also listed in the National Register of Historic Places in 1976 as a significant example of an historic Victorian-era cemetery.

The cemetery is beautiful and peaceful, yet mysterious. How did these people come to be buried at Oakland? Why do some graves feature elaborate markers, while those buried at Potter's Field have no markers? A visit through this sacred place is a walk through the history of Atlanta. Hundreds, later thousands, of people made their way to a small Southern railway town in their quest for the American dream of freedom and fortune. Oakland Cemetery became the final resting place for a cultural melting pot of people from all walks of life. Buried at the cemetery are immigrants from Africa and Europe; wealthy businessmen and paupers; famous people; prominent community leaders; and unknown soldiers.

Known as Terminus in 1837, the town was incorporated as Marthasville in 1843, named in honor of Gov. Wilson Lumpkin's 16-year-old daughter Martha. Her fame was short-lived, however; the charter was amended renaming Marthasville as Atlanta in 1845. Judge John Collier documents to charter Atlanta as a city in 1848. Both Martha Lumpkin Compton and John Collier are interred in Oakland's Original Six Acres.

Atlanta's first community graveyard was located at Peachtree and Baker Streets in what is now the heart of downtown Atlanta. With the city's population nearing 2,500, the need for a larger burial ground became apparent. Oakland Cemetery is the city's second municipal burial place. Six acres in a rural area southeast of downtown were purchased from A.W. Wooding in 1850 for $75 an acre by the city's fathers. The land was surveyed and families began to purchase plots. As graves were removed from the first city graveyard for development, many remains were interred at Oakland. After seven additional expansions, the cemetery reached its current size of 88 acres on October 9, 1867. Originally known as either Atlanta or City Cemetery, the name was changed to Oakland Cemetery in 1872 because of the proliferation of oak trees located on the grounds.

Within Oakland's 88 acres, several distinct sections have emerged. The Original Six Acres is the site of the oldest burials in the cemetery, including the first two burials of Agnes Wooding and James Nissen in 1850. During the Civil War, large tracts of land were assigned for the

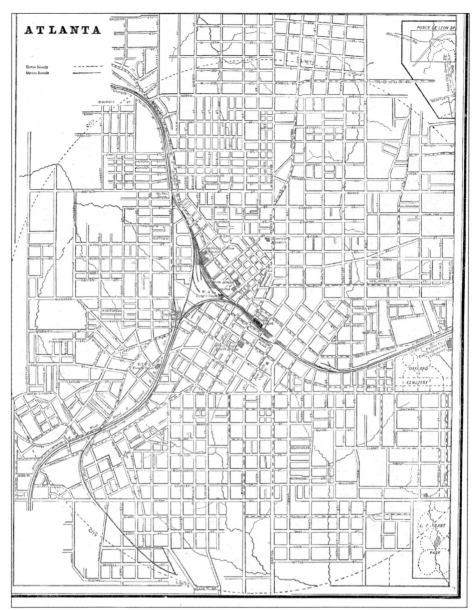

Oakland Cemetery can be seen on the right edge of this historic map of Atlanta. The cemetery was located in the southeastern corner of the city, at the border of the city limits. Memorial Drive was still known as Fair Street and Oakland's neighbor, Fulton Bag & Cotton Mill, was known as the Fulton County Cotton Spinning Company.

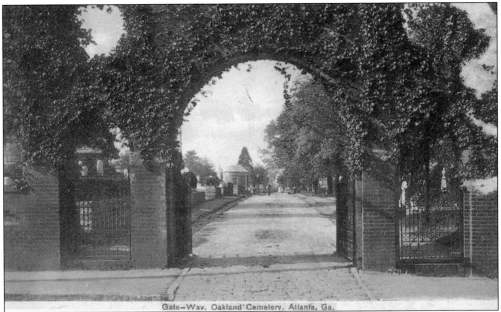

Gate—Way. Oakland Cemetery, Atlanta, Ga.

Produced in the 1900s, this postcard shows Oakland's Fair Street Gate (Fair Street is now called Memorial Drive) before the iron canopy was added in the 1920s. The Fair Street Gate served as the original entrance to the cemetery. It is located on the eastern side of the Original Six Acres and is closed to visitors today.

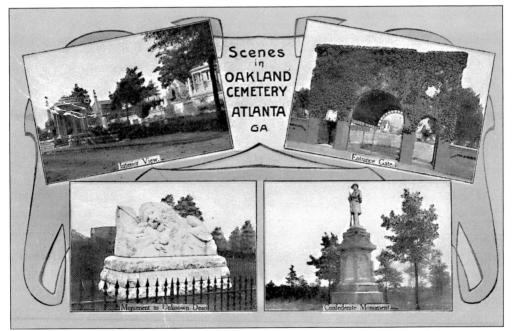

This historic postcard shows the Confederate Monument; a central view of the cemetery, including the Dodd Mausoleum; and the original Fair Street Gate (now Memorial Drive). The iron canopy shown just inside the Fair Street gate was added c. 1920. The canopy and circular openings at the top of the gate were removed sometime after 1933.

GEORGIA,

FULTON COUNTY,

CITY OF ATLANTA.

This Indenture, made this 12th day of July in the year of our Lord one thousand eight hundred and Fifty Eight, between the Mayor and Council of the City of Atlanta, and County and State aforesaid, of the one part, and Francis M Wells of the County of Fulton State of Georgia of the other part, Witnesseth, that the said Mayor and Council of the City of Atlanta, for and in consideration of the sum of Ten Dollars, to them in hand paid, at and before the sealing and delivery of these presents, the receipt whereof is hereby acknowledged, hath granted, bargained, sold, and conveyed, and do, by these presents, grant, bargain, sell, and convey, unto the said Francis M Wells his heirs and assigns, Cemetery Lot in the City Cemetery, known as No. 334 three hundred & thirty four in the survey made by H. L. CURRIER, City Surveyor, on the 20th day of July, 1857; TO HAVE AND TO HOLD the said Lot, unto him the said Francis M Well his heirs and assigns for the purpose of sepulture forever, in fee simple. And the said Mayor and Council of the City of Atlanta, for themselves, and for their successors in office, the said Lot unto the said Francis M Wells will warrant and forever defend the right and title thereof against themselves and against all other persons whatever.

In testimony whereof, the Corporate Seal is hereunto affixed.

ATTEST:

Luther J Glenn Mayor.

C. C. Howell Clerk.

This historic deed shows the purchase of Lot 334 in Oakland by Francis M. Wells on July 12, 1858. Mr. Wells paid $10 for the lot, which he sold to J.K. Thrower in 1882. The first person buried on the lot was Mrs. Mattie Thrower on August 29, 1882. She was 33 years old. Eleven people are documented as having been buried in Lot 334.

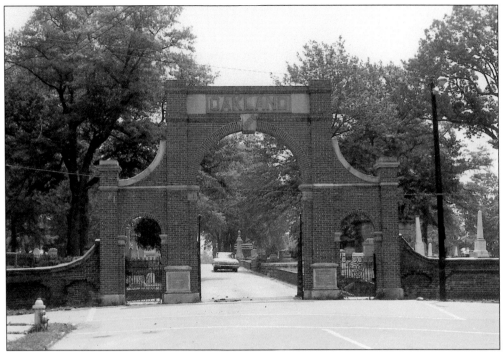

This view of the Hunter Street Gate at Oakland Avenue was taken before Hunter Street was renamed Martin Luther King Jr. Drive, possibly in the 1960s. The gate leads to the section known as the Original Six Acres, probably the only six acres of land in Atlanta that remain virtually unchanged since 1850.

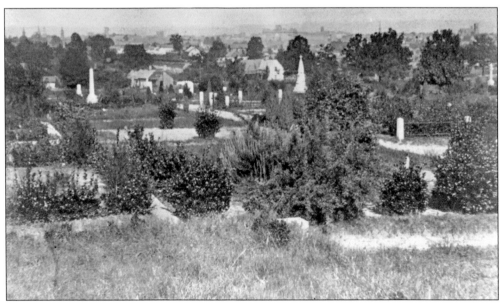

This historical photograph of Oakland by W.J. Land (c. 1895) was published in Rosenberg's *History of Photography in Atlanta*. The development of the City of Atlanta can be seen off in the distance of this northwestern view (top of photograph). It was typical for grass to be ankle-high throughout the cemetery, as shown in the foreground. (Courtesy of Atlanta History Center.)

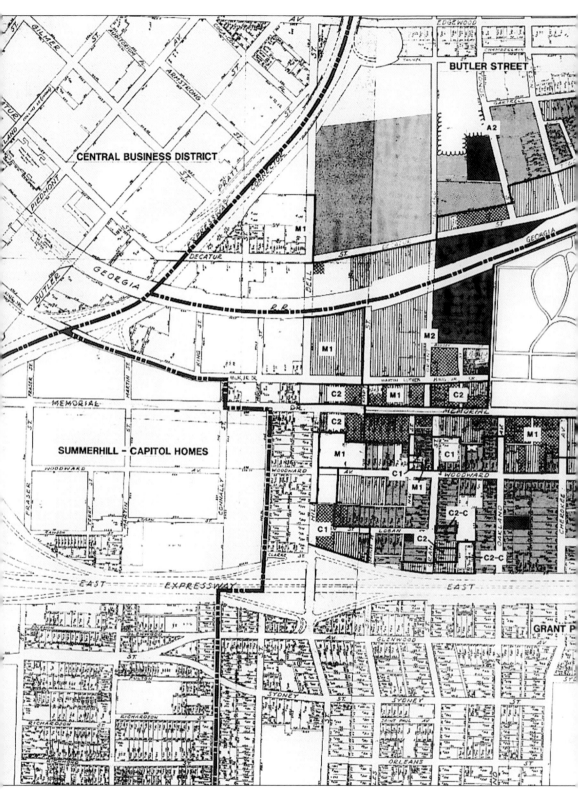

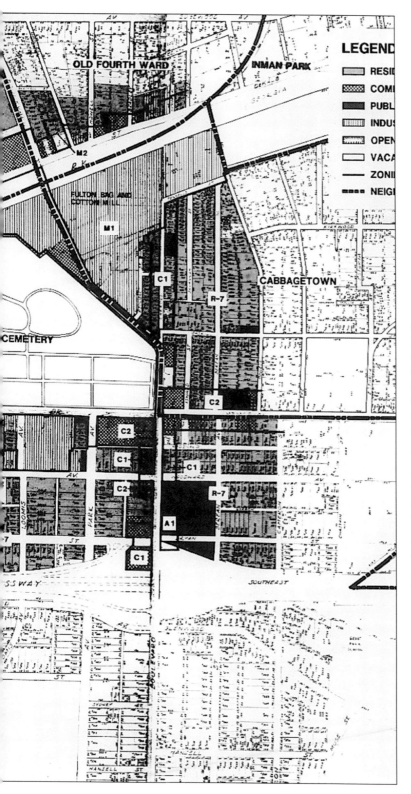

OLD FOURTH WARD

INMAN PARK

LEGEND

RESID
COM
PUBL
INDUS
OPEN
VACA
ZONI
NEIGH

M2

FULTON BAG AND COTTON MILL

M1

C1

R-7

CABBAGETOWN

CEMETERY

C2

C2

C1

C2

C1

R-7

A1

C1

SSWAY

SOUTHEAST

Oakland Cemetery is located approximately one mile east of the Georgia State Capitol. Some of Atlanta's oldest neighborhoods surround the cemetery, including the Old Fourth Ward, Grant Park, and Cabbagetown, where the Fulton Bag & Cotton Mill was recently converted into loft apartments. This 1994 Land Use & Zoning map, prepared by Laubman-Reed & Associates, exemplifies the variety of entities located just outside of the cemetery's walls: MARTA, Atlanta's rapid rail system; the Central & Southern rail yard; many small businesses; a few restaurants; and several industrial conversions to loft apartments.

15

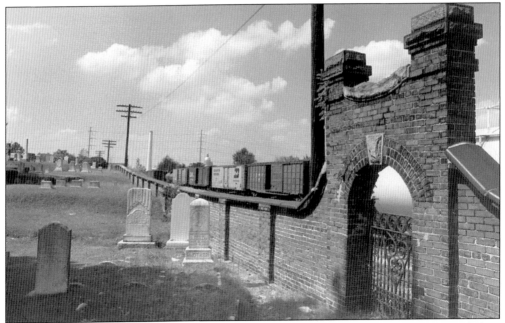

Showing the northwestern corner of Oakland Cemetery and a view of downtown, including the Georgia State Capitol, the above photograph was taken c. 1950—before the days of massive skyscrapers and rapid-transit trains. The railroad tracks border the north side of the cemetery. In 1837, Atlanta was known as Terminus because the railroad lines terminated here. In 1843, the name was changed to Marthasville in honor of Governor Lumpkin's daughter Martha. The town was finally named Atlanta in 1845. In contrast, the picture below shows how Oakland Cemetery has stood silently by as Atlanta has developed into a bustling metropolis over the past 150 years. (Bottom photo by R. Craig Scogin.)

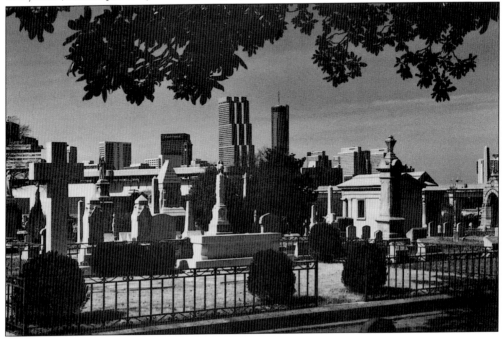

BURIAL PERMIT.

No. 767 ATLANTA, GA., JUN 21 1901 190

Official permit is hereby granted for the removal of the body of the following described person for interment at *Oakland* Cemetery.

Name *James E. Owens* Age *35* Years *11* Months *14* Days

Sex *male* Color *White* Nativity *U. S.*

Occupation *Bartender* Married, single or widowed *Married*

Residence: No. *Portsmouth Va* Cause of death *cirrhosis of liver*

Date of death *June 18* 190*1*. Certified *J. H. Richardson* M. D.

John Redd *Health*

If interment is in Oakland, this permit is void unless receipted on back by City Tax Collector for burial fee. FOR THE BOARD OF HEALTH.

BOARD of HEALTH, CITY of ATLANTA

Pictured above is a City of Atlanta burial permit for James Owens to be interred at Oakland. He died at age 35 on June 18, 1901. According to the document, he was a resident of Portsmouth, Virginia, and died of cirrhosis of the liver. His occupation was listed as bartender. The reverse side of the 1901 burial permit, pictured at right, shows that C.H. Swift received $4 for the City Tax Collector's office so that Mr. Owens could be buried. In pencil, the cemetery sexton has written "Block 241-Lot 1" as the space for Mr. Owens. James E. Owens Sr. purchased the plot on May 27, 1874.

OFFICE OF CITY TAX COLLECTOR.

Atlanta, Ga., 6/21/190 1

Received of *C H Swift*

Four Dollars,

Burial fee for *Owens*

in Oakland Cemetery.

C. F. Payne.

City Tax Collector.

Block - 241 - Lot - 1

2 - 5 - 6 - 6 - 6

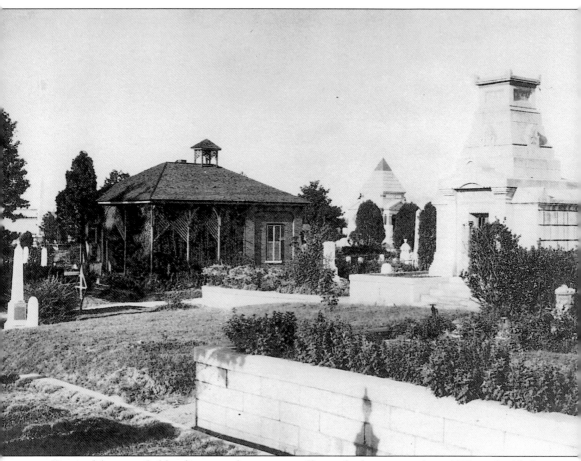

Pictured here is Oakland's original cemetery office, which was razed in 1899 to build the current Bell Tower Building. The Rawson Mausoleum is shown on the right, with the top of the Grant Mausoleum visible behind the Rawson Mausoleum and the office building. An article in the January 14, 1899 edition of the *Atlanta Constitution* reported that the existing building, "which has served as the office for the past few years," was too small for the cemetery office and that Mayor Woodward proposed "to make the [new] structure a handsome one [that] would be an honor to the city." Construction was begun on April 27, 1899, following Confederate Memorial Day on the 26th. (Courtesy of Atlanta History Center.)

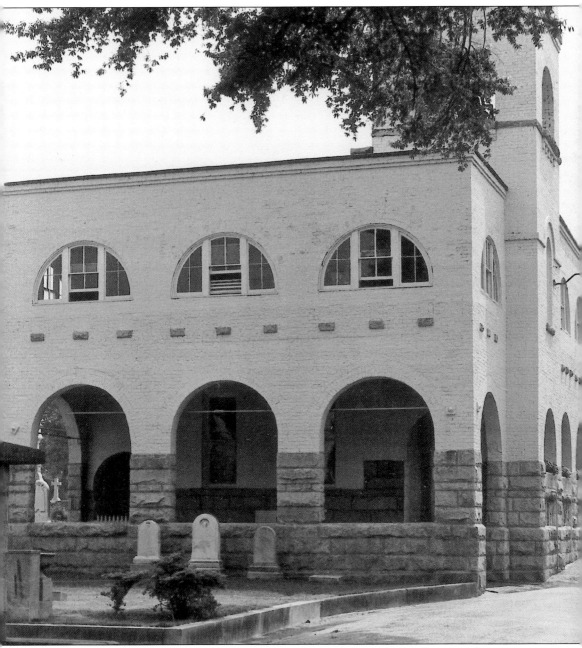

The new Bell Tower Building was constructed in 1899 on the same site as the original cemetery office, shown on the opposite page. The Atlanta Building Company was awarded the contract after submitting the lowest bid, which was $4,500. The two-story building was modeled after the Norman and English castellated churches. The tower is 50 feet high and still contains its bell, which is rung whenever the sexton is notified of an upcoming funeral. The structure includes a receiving vault in the basement, a sexton's office and visitors' room on the first floor, and an apartment for the sexton on the top floor. The visitors' room has since become the sexton's office and the former office is now a gift shop. Restored in 1998, the Bell Tower Building's top floor serves as offices for the Historic Oakland Foundation.

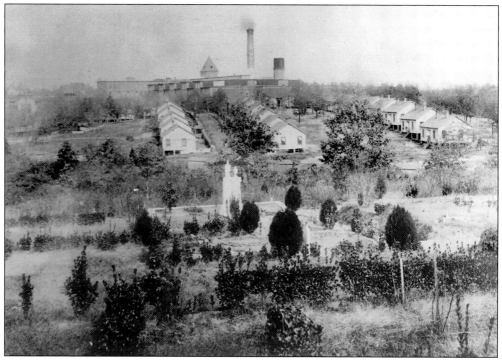

The 1890s photograph above shows the mostly undeveloped northeastern quadrant of the cemetery, with the neat houses of the mill village known as Cabbagetown and Fulton Bag & Cotton Mill in the distance. (Courtesy of Atlanta History Center.)

Looking down the steps leading underneath the Bell Tower Building one can see the gates of the receiving vault. The vault has receptacles for 15 bodies, which were formerly used to store corpses in the event of inclement weather.

Pictured on the porch of the Bell Tower Building is an agave, or century plant, which was popular during the Victorian era. The plant is shown in a reproduction concrete urn. Many historic and symbolic plants and trees are found throughout the cemetery. Newly landscaped family plots feature historic plant materials, such as old varieties of roses and privet and boxwood hedges. (Photo by Marla Bexley-Lovell, 2000.)

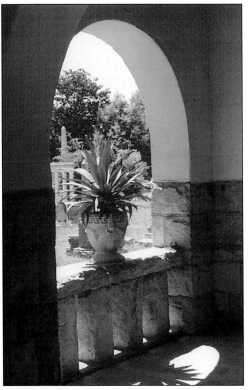

The porch of the Bell Tower Building was constructed of granite and brick walls with a marble floor, as seen in this 1970s photograph. Underneath the porte-cochere on the western side is a stone commemorating the completion of the 1899 building, naming G.W. Smith as the architect of the project.

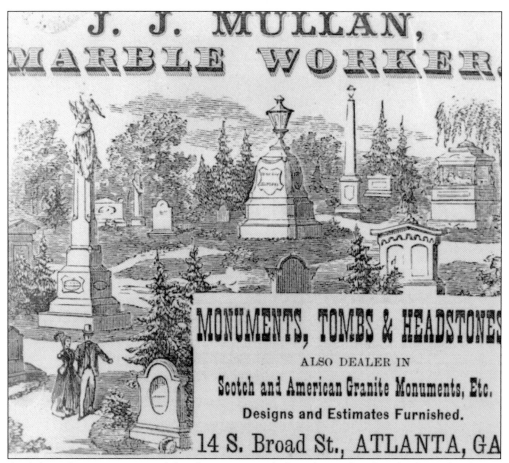

As Atlanta began to grow, so did its businesses, including those related to the funeral industry. Shown above is an advertisement for J.J. Mullan, Marble Worker. Below is an advertisement for the Frigid Fluid Company of Chicago. Embalming fluid and supplies were shipped via railroad to Atlanta to prepare bodies for burial.

S. B. OATMAN,

MARBLE DEALER.

MONUMENTS,

TOMBS,

HEAD-STONES,

MANTELS,

VASES,

Furnishing Marble.

South of the Georgia Railroad Depot, Atlanta, Georgia.

Above is another vintage advertisement for a monument company. Pictured below is a piece of cemetery letterhead from the early 1900s. The Cemetery Commission was formed in the 1870s and reported to the mayor and city council. Currently, the cemetery's sexton, or manager, handles all records and burials and reports to the City of Atlanta Bureau of Parks.

C. G. MITCHELL, CHAIRMAN
FRANK HILL, SECRETARY
W. F. CRUSSELLE
P. J. BLOOMFIELD
J. A. PRITCHARD

J. N. PORTER, GENERAL

CITY OF ATLANTA

Office of

Cemetery Commission

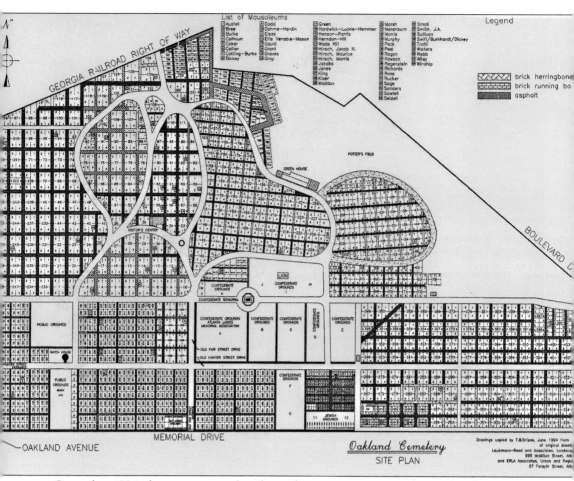

Drawings copied by T.B.Snipes, June 1994 from of original drawi Laubmann—Reed and Associates, Landsca 995 McMillon Street, Atl and ERLA Associates, Urban and Regio 57 Forsyth Street, Atl

Oakland Cemetery
SITE PLAN

Created in 1994, this current site plan shows the entire cemetery and is used to locate graves, paving surfaces, and the 54 mausolea and vaults constructed by families to inter their loved ones. The Old Hunter Street Entrance, shown on the left side of the map, serves as the current entrance to the cemetery. The first lots to be surveyed are identified by a single number, such as Lot 302. As the cemetery expanded, a new numbering system was adopted, using a block and lot number to identify family plots. For example, "Block 37, Lot 1" is the site of the Cotting-Burke Vault. Further complicating the issue is the fact that some block numbers were duplicated in both the general areas of the cemetery and the area known as the Black Section from the days of segregation.

The Kiser and Richards mausolea can be seen in this historic photograph, which also features traditional hedges to differentiate one family lot from another. (Courtesy of Atlanta History Center.)

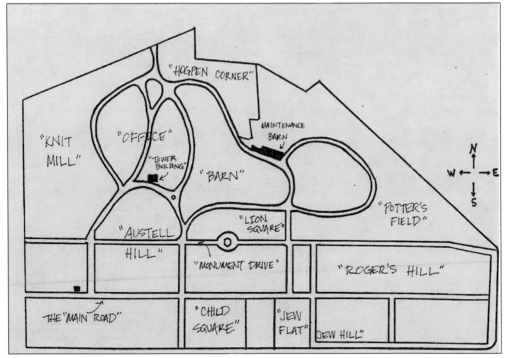

This map shows the old nicknames from the various parts of the cemetery. The names "Austell Hill," "Lion Square," "Monument Drive," and "Potter's Field" are still used today.

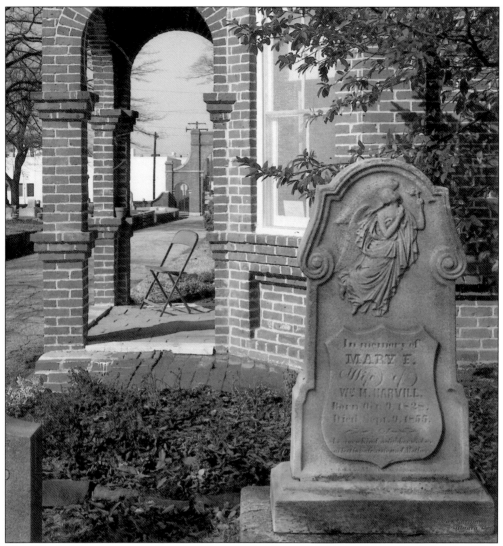

The Watch House, commonly referred to as the Guard House, was constructed of brick in 1908. Seen in the distance through the archway on the porch is the Hunter Street Gate, which was built in 1896 and serves as the present entrance to the cemetery. In the foreground is the headstone for Mary E. Harvill, who was born in 1826 and died in 1855. The angel at the top of the headstone represents death and resurrection and looks skyward toward heaven.

MAYORS OF ATLANTA
1848 — 1976

MOSES W. FORMWALT
1848
BENJAMIN F. BOMAR
1849
WILLIS BUELL
1850
JONATHAN NORCROSS
1851
THOMAS F. GIBBS
1852
JOHN F. MIMS
1853
WILLIAM MARKHAM
1853
WILLIAM M. BUTT
1854
ALLISON NELSON
1855
JOHN GLEN
1855
WILLIAM EZZARD
1856—1857, 1860, 1870
LUTHER J. GLENN
1858 — 1859

The Mayor's Monument lists all of Atlanta's mayors from 1848 until 1976. Another block will soon be added to update the list and allow space for future mayors. This small monument is sited just north of the Bell Tower Building. Moses Formwalt, the city's first mayor in 1848, is one of the 24 Atlanta mayors buried at Oakland.

DAVID M. DEAKINS WALK

As seen in this photograph, the City of Atlanta began laying hundreds of linear feet of brick walkways and gutters in Oakland in the early 1900s. As a cemetery fundraiser in the 1980s, several families donated funds for memorial markers that were placed in many of the sidewalks. (Photo by Phillip Lovell, 2001.)

27

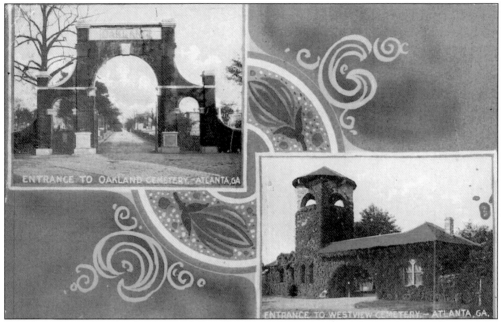

Established in 1850, Oakland served as Atlanta's exclusive municipal cemetery until Westview Cemetery opened in October 1884 to relieve the pressure on Oakland. Both cemeteries still have burials today. Oakland is a fabulous example of the rural cemetery movement, which started at Mt. Auburn in Boston in 1831. Unlike crowded church graveyards, these "rural" cemeteries were constructed away from downtown areas, where more land was available, and served as parks.

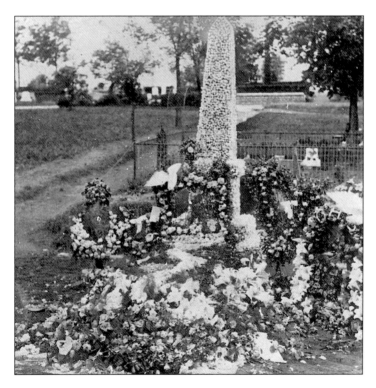

Even the obelisk next to a new grave is covered with flowers following a funeral, c. 1894. The obelisk represents eternal life. (Courtesy of Robert Basford.)

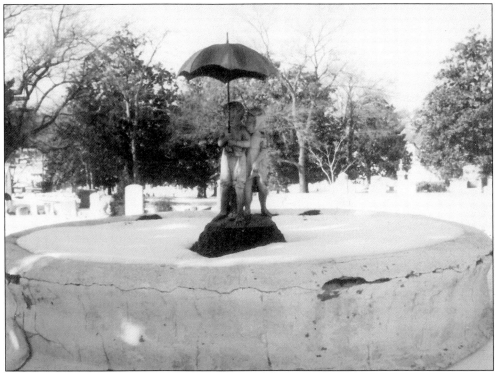

Both the Bell Tower Building and the fountain were originally covered in stucco. The above photograph also shows the pool of the fountain covered in snow, an unusual occurrence at Oakland. According to the chronological cemetery records, the remains of Moses Formwalt, Atlanta's first mayor, were "cemented in fountain" on May 26, 1916. (Photo by Katherine A. Breck.)

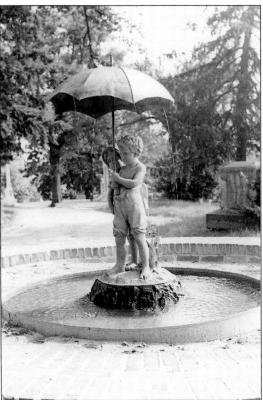

Finished in bronze, Out in the Rain was placed in its pool in 1913. Correspondence between T.G. Spearman at 405 Hunter Street and N.M. Clayton at J.L. Mott Iron Works of New York City shows that the fountain was packed in straw and shipped in three crates from Trenton, New Jersey, on June 11, 1913. The umbrella was slightly damaged in transit, but was repaired.

Oak and magnolia trees thrive among the headstones and monuments at Oakland, once known simply as City Cemetery. The annual report of the 1872 Cemetery Commission states, "In all cities of any note, and in some much smaller than ours, when their cemeteries probably have not reached as high a state of cultivation and improvements, they have thought it right and proper to name them . . . and thereby we suggest that hereafter it be known and called Oakland Cemetery."

BY THE GOVERNOR OF THE STATE OF GEORGIA

A PROCLAMATION

HISTORIC OAKLAND CEMETERY
150th ANNIVERSARY

WHEREAS: Oakland Cemetery, established in 1850 in the City of Atlanta, will celebrate its 150th anniversary on September 22, 2000, as an important historical resource for the South, our state and capital city; and

WHEREAS: The Cemetery has been recognized as a Victorian-era cemetery of national importance and in 1976 was listed on the National Register of Historic Places in addition to its locally-designated historic district by the City of Atlanta; and

WHEREAS: Oakland Cemetery serves as the final resting place for more than 70,000 people of all ages and ethnic, social and economic backgrounds, including six Georgia governors, 24 mayors of Atlanta and numerous Confederate and Union soldiers of the Civil War; and

WHEREAS: Oakland Cemetery also serves as a public park and historic landscape filled with significant statuary, architecture and symbolism as well as an educational resource in which to study Georgia's history; and

WHEREAS: Over the course of its 150 years, Oakland Cemetery has survived the ravages and challenges of war, vandalism, time and neglect to remain Atlanta's oldest permanent landmark; now

THEREFORE: I, ROY E. BARNES, Governor of the State of Georgia, do hereby recognize HISTORIC OAKLAND CEMETERY on the occasion of its 150th anniversary.

IN WITNESS WHEREOF, I have hereunto set my hand and caused the Seal of the Executive Department to be affixed this eighth day of August in the year of our Lord two thousand.

GOVERNOR

ATTEST

CHIEF OF STAFF

Established in 1850, Oakland Cemetery celebrated its 150th anniversary in the fall of 2000 during the annual Sunday-in-the-Park Victorian cemetery celebration. The event was dedicated to the memory of the late Franklin M. Garrett, Atlanta's official historian and Historic Oakland Foundation trustee.

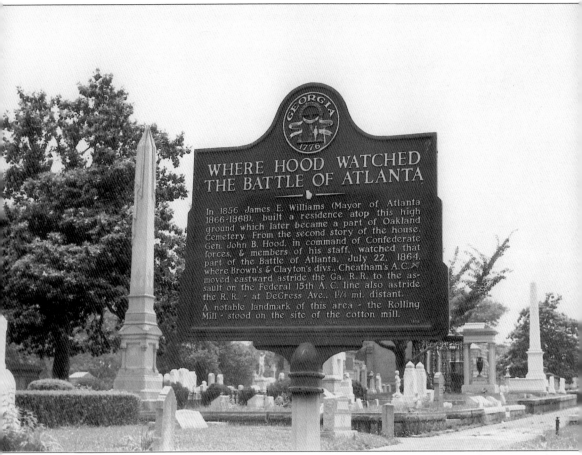

GEORGIA
1776

WHERE HOOD WATCHED
THE BATTLE OF ATLANTA

In 1856 James E. Williams (Mayor of Atlanta
1866-1868), built a residence atop this high
ground which later became a part of Oakland
Cemetery. From the second story of the house,
Gen. John B. Hood, in command of Confederate
forces, & members of his staff, watched that
part of the Battle of Atlanta, July 22, 1864,
where Brown's & Clayton's divs., Cheatham's A.C.
moved eastward astride the Ga. R.R. to the as-
sault on the Federal 15th A.C. line also astride
the R.R. - at DeGress Ave., 1¼ mi. distant.
A notable landmark of this area - the Rolling
Mill - stood on the site of the cotton mill.

Pictured here is the historical marker that tells the story of the farmhouse where General Hood stood on the second floor and watched the Battle of Atlanta begin on July 22, 1864. James E. Williams, mayor of Atlanta from 1866 until 1868, built the house in 1856. The site became part of the cemetery when the City purchased the land from Lewis Schofield on September 8, 1866.

The monument on the right reads, "A Memorial to the Citizens of Atlanta Who are Buried in Unmarked Graves." Potter's Field, a grassy, 7.5-acre field located on the eastern side of the cemetery, is where an estimated 17,500 people, mainly paupers, were buried until approximately 1900. The graves were originally marked by wooden crosses, which eventually deteriorated and were never replaced. (Photo by Phillip Lovell, 2001.)

An oasis of history, trees, and green space, Oakland Cemetery served as Atlanta's first park. It is currently the city's third largest green space. Sometimes shabby, but always beautiful, Oakland is not a perpetual care cemetery. Each family is responsible for the maintenance and repairs of their own plot. Unfortunately, broken markers can be found throughout on the grounds and are restored as funds become available.

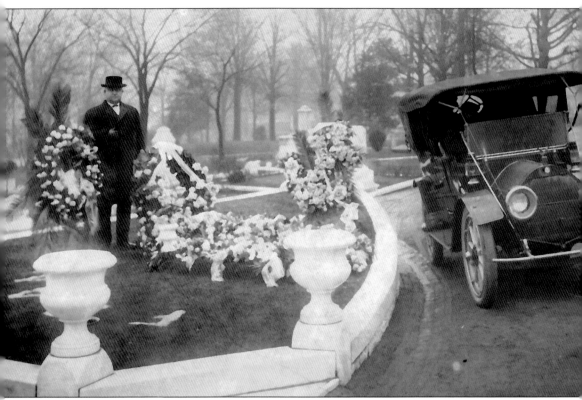

Pictured is the Thomas F. Stocks lot following the burial of Mrs. Diamond Edwards Stocks in January 1913. Standing on the lot is her husband, Thomas F. Stocks III. The man standing to the right of the Premier Automobile is the brother of the deceased. Diamond Edwards Stocks was born on November 30, 1873, and died on January 8, 1913. (Courtesy of Stocks family.)

Two

MAGNIFICENT MAUSOLEUMS

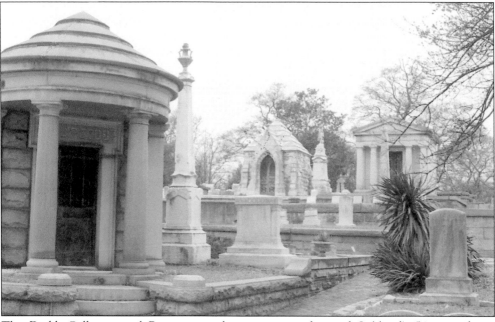

The Dodd, Calhoun, and Ragan mausoleums are just three of Oakland's 54 magnificent mausolea. Fifty-three of the fifty-four—all but the mausoleum of Antoine Graves—were constructed prior to the Great Depression. These structures are testaments to the prosperity of the people interred within. The word "mausoleum" is derived from the name Mausolus, ruler of Asia Minor during the fourth century B.C., for whom a huge tomb was built following his death. The huge tomb, with its pyramidal roof, was so impressive that its name, Mausoleum, has become a generic term for all outsized funerary monuments, according to H.W. Janson's *History of Art*, published in 1977.

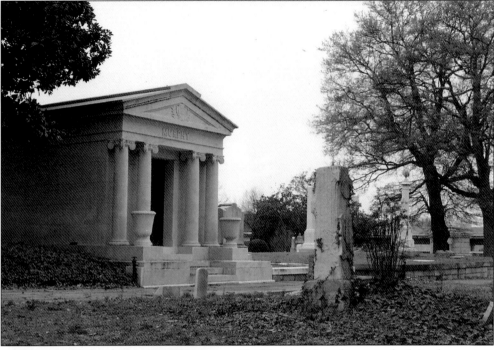

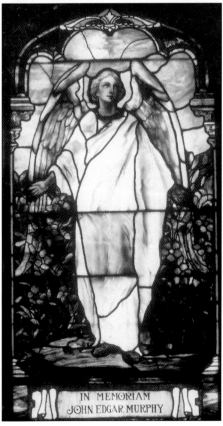

IN MEMORIAM
JOHN EDGAR MURPHY

The Murphy Mausoleum was built in the Classical Revival style, which is based on ancient Greek and Roman temples, featuring pediments, classical columns, dentil motif, and triglyphs. Constructed of smooth marble, the egg-and-dart motif on the column capitals represents life and death or the beginning and the end.

This beautiful stained-glass window on the back side of the Murphy Mausoleum was placed in memory of John Edgar Murphy, who died in January 1924 at age 62.

The Grant Mausoleum is a beautiful example of the eclectic style, which combines design elements from different styles of architecture. The pyramidal roof is topped with a polished granite cap. Interments include Gov. John Marshall Slaton, who died in 1955; Hugh Inman Grant, who died in 1906 at age 11 and for whom Georgia Tech's Grant Field is named; William D. Grant, a contractor and builder of the Grant Building; John T. Grant, a contractor and builder who died in 1887; and John W. Grant, a prominent real estate owner who died in 1938. (Photo by Phillip Lovell, 2001.)

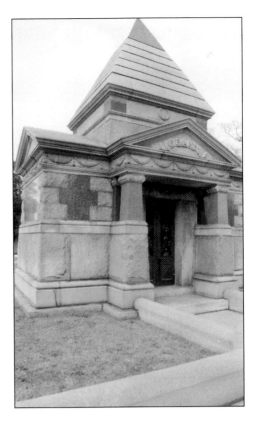

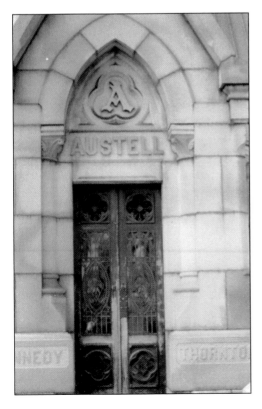

An article in the June 17, 1883 issue of the *Atlanta Constitution* states that the Austell Kennedy Thornton Mausoleum was constructed in 1883 at a cost of $16,000. Built in the Gothic Revival style of Westerly granite and Italian marble, the medallion of General Austell's likeness was carved by the artist Nicoll of Cararra, Italy. Alfred Austell died on December 7, 1881. He founded the Atlanta National Bank in 1865, which has since become Wachovia Bank. Albert E. Thornton, also interred in this mausoleum, was president of Elberton Oil Mills and a son-in-law of Alfred Austell.

Shown in this historic photograph are the John Kiser monument and the Kiser and Richards Mausolea. Both the M.C. Kiser and the Richards structures are built in the Romanesque Revival style. (Courtesy of Atlanta History Center.)

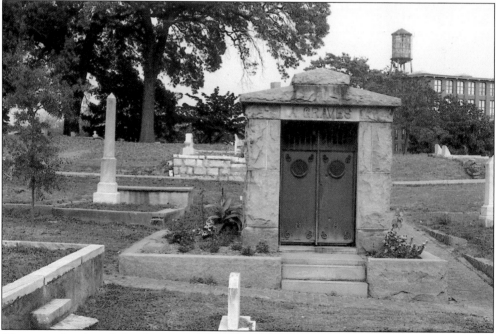

Constructed with rock-faced granite slabs following the death of Antoine Graves in 1941, the Graves Mausoleum is designed in the eclectic style. It is the only mausoleum located in the Black Section of the cemetery.

A close-up photograph of the Kiser Mausoleum shows the beautiful details of the crested roof, windows, turrets, polished granite piers, and rock-faced walls.

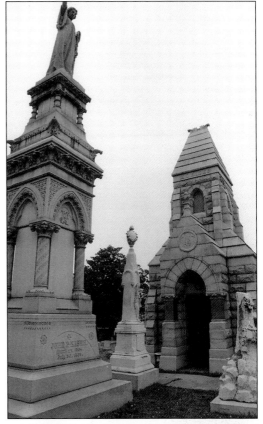

Marion C. Kiser, whose bust is on display within the Kiser Mausoleum, died in 1893. He was a wholesale dry goods merchant and one of Atlanta's wealthiest and most respected residents. (Photo by Phillip Lovell.)

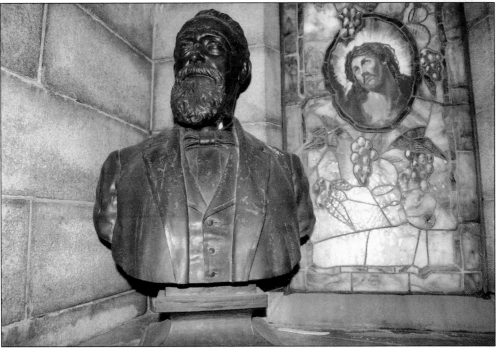

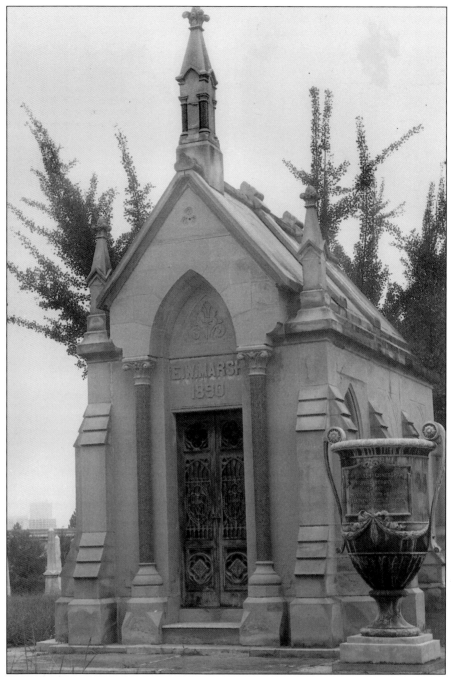

Constructed in 1890 of sandstone with polished granite shafts, the E.W. Marsh Mausoleum is an example of Gothic Revival architecture. Exposed buttresses, cusped arches, and a spire are combined to create this impressive structure. Gorham Manufacturing, the first U.S. foundry, constructed the two bronze urns in 1895 and 1896. Edwin W. Marsh died in 1900. Like Mr. Kiser, he was a wealthy wholesale dry goods merchant. Mary Marsh Crankshaw died in 1895, within a year of marrying Charles Weir Crankshaw (d. 1924). A bronze bowl commemorating what would have been their first wedding anniversary remains inside the mausoleum.

A pair of these six-foot bronze urns flanks the entrance to the Marsh Mausoleum. The urns are dated 1895 and 1896 and are filled with symbolism. Ivy entwined at the base of the urn represents abiding memory and fidelity. The sunflowers at the top of the handles are for prosperity. The egg-and-dart-motif around the rim symbolizes birth and death.

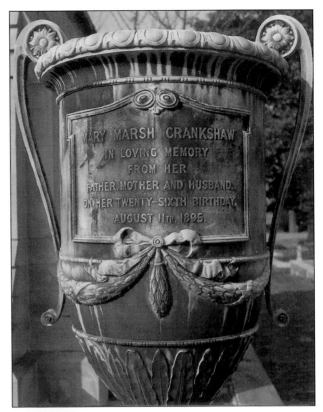

MARY MARSH CRANKSHAW
IN LOVING MEMORY
FROM HER
FATHER, MOTHER AND HUSBAND,
ON HER TWENTY-SIXTH BIRTHDAY,
AUGUST 11TH, 1895.

In contrast to the elaborate Marsh Mausoleum, the modest Waid Hill Mausoleum is the only mausoleum constructed of brick. It was completed in 1876. R.P. Hill shot his brother, O.C. Hill, and then killed himself in the late 1800s. They are buried together in an unmarked grave next to the family mausoleum.

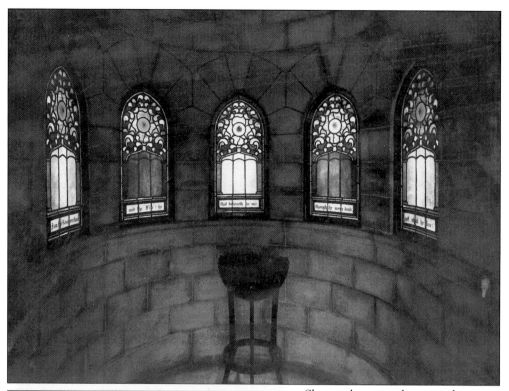

Shown above are the stained-glass windows in the Richards Mausoleum. The scripture, divided among the five windows, says, "I am the Resurrection and the Life; he that believeth in me, though he were dead, yet shall he live." (Photo by J. Weiland.)

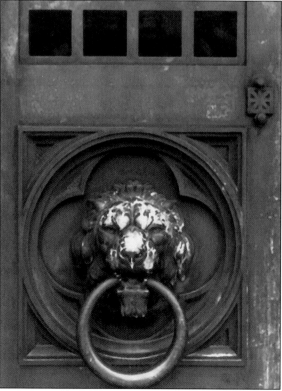

Bronze doors, such as these at the Richards Mausoleum, are typically installed in each mausoleum. These menacing lion door pulls match the lion heads on the gargoyles.

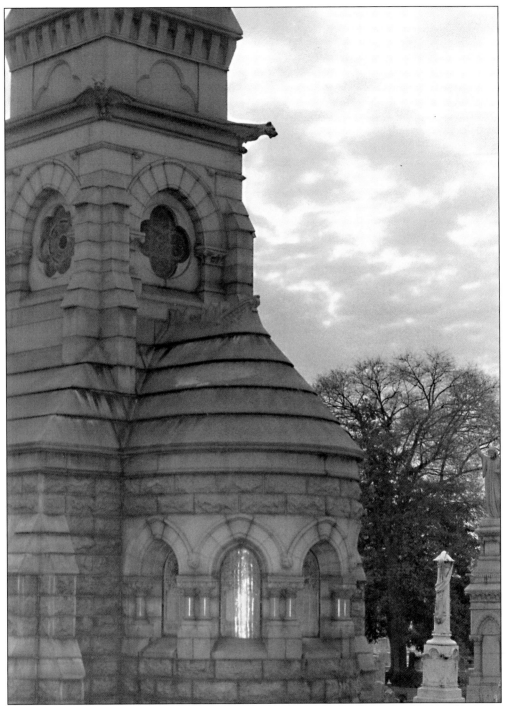

Often called the most beautiful mausoleum at Oakland by visitors, the Richards Mausoleum was built by H.Q. French of New York City for Robert H. Richards, a London-born entrepreneur and co-founder of Atlanta National Bank with Alfred Austell. Richards died on September 16, 1888. The structure's gargoyles feature lion heads and bat wings and talons. They are intended to frighten away evil spirits. (Photo by R. Shane Garner.)

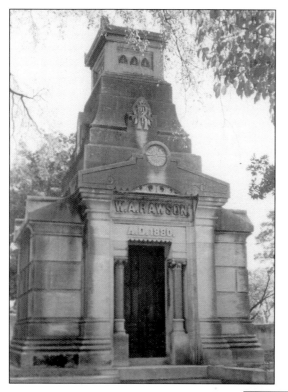

The Rawson Mausoleum was constructed in 1880. The Rawson family and their descendants were prominent Atlantans. Interments include William A. Rawson, who died in 1919 and was a merchant and property owner, and Mayor Charles Collier.

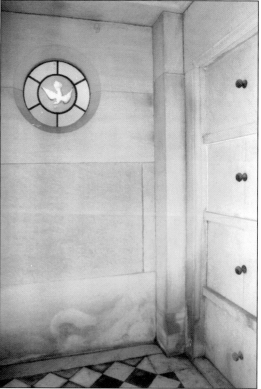

The round stained-glass window inside the Rawson Mausoleum features a dove, which symbolizes peace. Also note the black-and-white tiled floor. An example of Exotic Revival architecture, this structure has elements of Greek Revival, including pilasters, or flat piers, attached to the walls and a pediment.

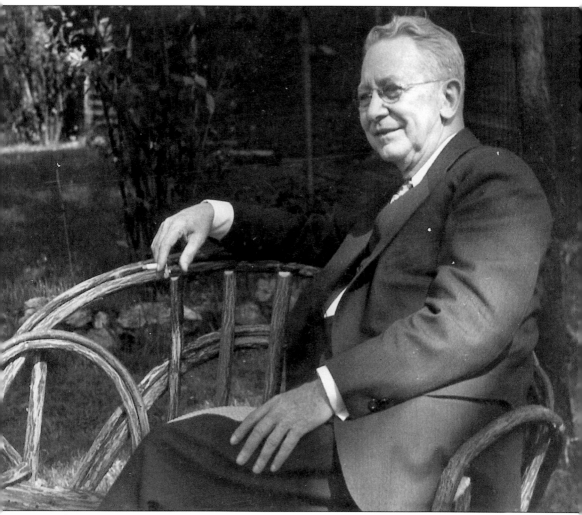

Award-winning writers Julia Collier Harris and Julian LaRose Harris (above) are also interred in the Rawson Mausoleum. Born November 11, 1875, Julia was the daughter of Charles and Susie Collier. She died in 1967. Julian, who died in 1963, was the son of author Joel Chandler Harris. Together, this husband and wife published the *Columbus* (Georgia) *Enquirer Sun*, which won the 1926 Pulitzer Prize for a series of articles and editorials about the Ku Klux Klan and the Scopes Monkey Trial. (Courtesy of Penny Hart.)

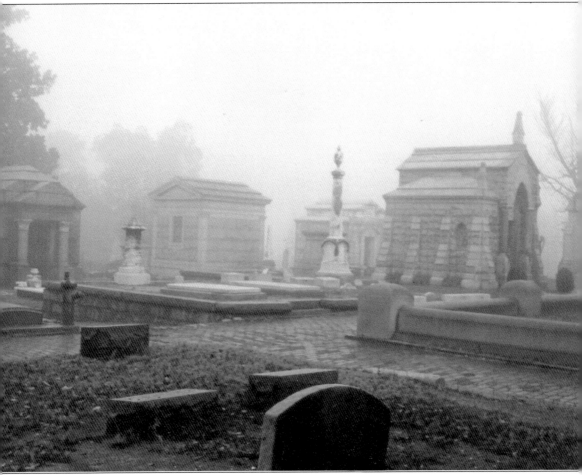

The mausolea seen in the mist are, from left to right, Gray, Sanders, Swift/Burkhardt, Maddox, and Marsh. Gray, Sanders, and Swift/Burkhardt all have classical elements, whereas Maddox is Romanesque Revival. Robert F. Maddox, who died in 1899, was a merchant and banker with the Maddox-Rucker Banking Company. Robert F. Maddox, Jr. served as mayor from 1909–1910. Also a banker, he died in 1965. (Photo by Cameron Adams.)

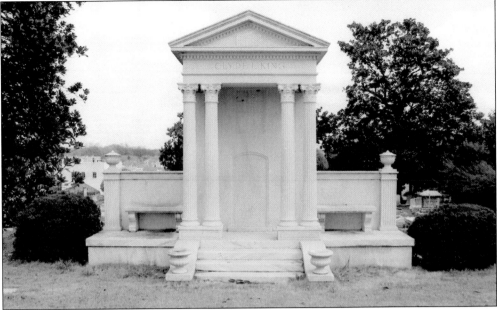

The Clyde L. King Classical Revival–style monument only appears to be a mausoleum or vault. Apparently, Clara Bell Rushton King loved her home at 1010 Ponce de Leon Avenue so much, her husband had a replica constructed at the cemetery. The original house is still standing.

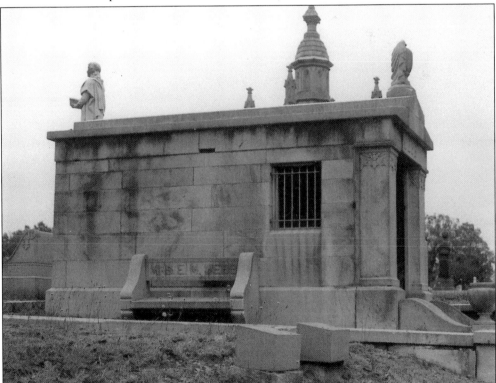

The Webb vault is constructed of traditional granite block and features a welcoming bench for visitors on the north side of the structure.

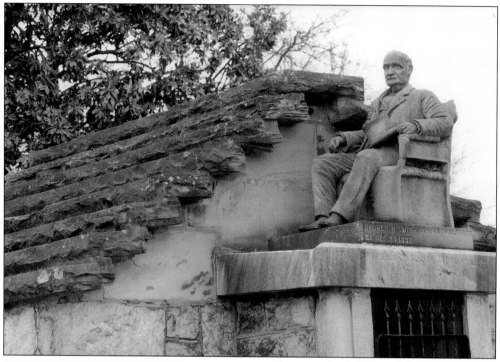

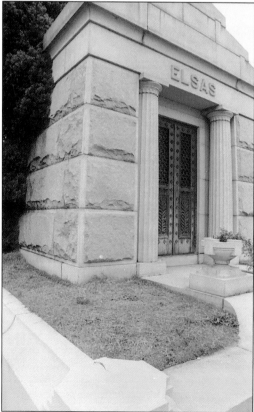

Known as "Jack," Jasper Newton Smith supervised the construction of his own mausoleum in 1906. This is the only mausoleum at Oakland with a statue of a person sitting on top; it was sculpted by C.C. Crouch. Jack Smith opened a brickyard after the Civil War and owned the Bachelor's Domain, an apartment house for men only, and the "House That Jack Built," at the corner of Peachtree and Carnegie Way. He died in 1918 at age 85.

The Elsas Mausoleum is built with rock-faced granite and has Greek Doric columns. A noted Jewish philanthropist, Jacob Elsas was the founder of Fulton Bag & Cotton Mill, located just across the boulevard from the cemetery.

Three

HIGHLIGHTS FROM OAKLAND'S SPECIAL SECTIONS

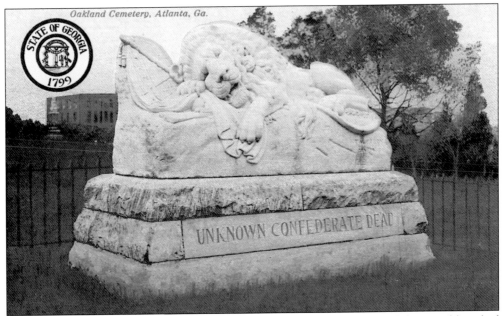

This Confederate Monument honors approximately 3,000 unknown Confederate soldiers laid to rest at Oakland. Erected by the Ladies Memorial Association and unveiled on April 26, 1894, the monument was carved by T.M. Brady of Canton, Georgia.

Located in the South Public Grounds in the section referred to as the Original Six Acres, this long-faded tablet marker was placed to mark the grave of Dr. James Nissen, who died in 1850. According to historian Franklin Garrett, "The young doctor, passing through Atlanta, died here and became the first direct interment in the new City Cemetery, as Oakland was then called." (Photo by Phillip Lovell, 2001.)

The 1896 Hunter Street Gate leads directly into the Original Six Acres. Note the towering oak trees for which the cemetery was renamed in 1872. Some of Atlanta's oldest family names are represented in this section, including Ivy, Carlisle, Forsyth, Ezzard, Bellingrath, and Simpson. (Photo by Phillip Lovell, 2001.)

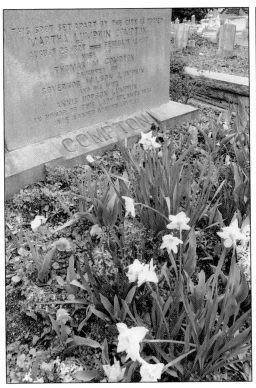

Above, left: First known as Terminus, the city was called Marthasville from 1843 to 1845 in honor of Gov. Wilson Lumpkin's daughter Martha. She was buried in Oakland when she died in 1917.

Above, right: More than 20 of Atlanta's mayors are buried at Oakland, including Charles Collier, who died in 1900, after he served as mayor of Atlanta from 1897 until 1898. He was married to William Rawson's daughter Susie, who died in 1897. (Courtesy of Penny Hart.)

Right: Judge John Collier died in 1892 and was interred inside the Collier Mausoleum, one of several mausolea constructed in the Original Six Acres. Noted lawyer and prominent citizen, Collier is best remembered for drawing up the charters to incorporate both the City of Atlanta and Fulton County. Ironically, Judge Collier and Martha Lumpkin Compton are buried just down the road from one another.

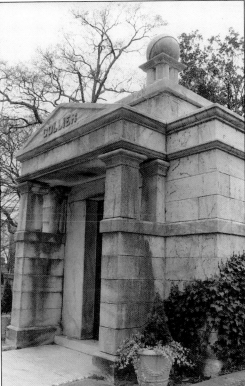

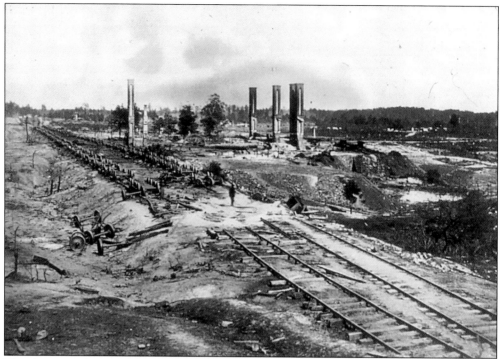

This historic photograph depicts the ruins of the city after the Battle of Atlanta in 1864. Mayor James C. Calhoun, buried at Oakland in 1875, surrendered the city to Union troops on September 2, 1864.

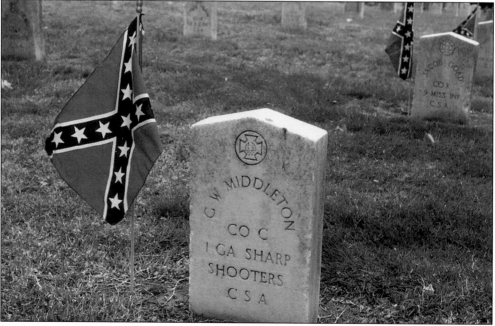

In the Confederate sections of Oakland, more than 6,500 Confederate soldiers are buried in rows with military headstones. Many other soldiers are buried throughout the cemetery on family plots.

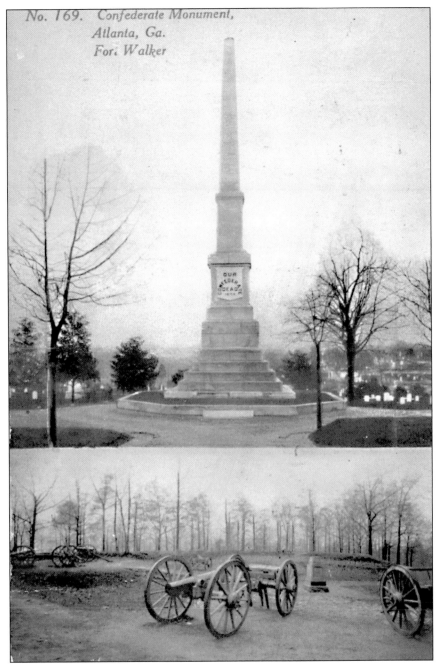

No. 169. Confederate Monument,
Atlanta, Ga.
Fort Walker

This historic postcard provides a view of the Confederate Obelisk, erected by the Ladies Memorial Association to honor the Confederate Army, in Oakland Cemetery (at top). The base of the monument was placed in 1870, and the obelisk was dedicated on April 26, 1874. Made from Stone Mountain granite, the obelisk was once the tallest structure in Atlanta, equal in height to a three-story building. The bottom portion of the postcard depicts Fort Walker. Located on Boulevard at Grant Park, it is part of the fortifications built by Lemuel P. Grant and was named in honor of Gen. William H.T. Walker. The fort is the last remaining artillery fort in Atlanta.

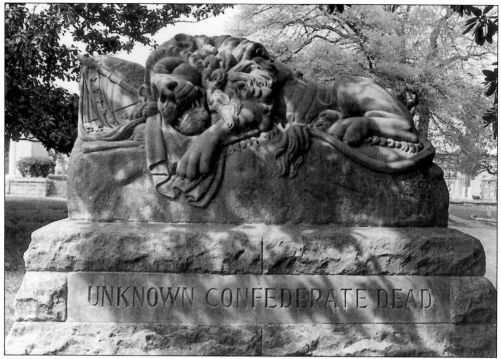

A modern photograph shows the Lion of Atlanta cast in shadows of the afternoon sun—the monument commemorates the unknown Confederate dead buried at Oakland Cemetery. Carved as a replica of the Lion of Lucerne in Switzerland, Oakland's monument features a dying lion, representing courage, shown with his head on a Confederate flag.

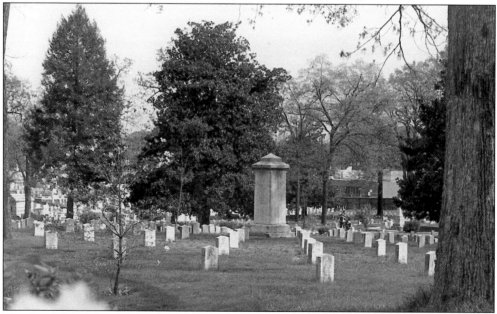

The Confederate Section is divided into eight areas. The large marker in the center of this area lists the names of those Confederates buried in Oakland. Approximately 6,900 Confederates and 16 Union soldiers were buried in this section. Others are located on family plots.

Pictured here is a 1960s view of the Confederate Obelisk. Crabapple and dogwood trees line the road to the monument. Looking much different from the image below, the Confederate Obelisk remains the site of Oakland's annual Confederate Memorial Day ceremony, during which military personnel with lineal Confederate soldiers or sailors as ancestors receive service awards.

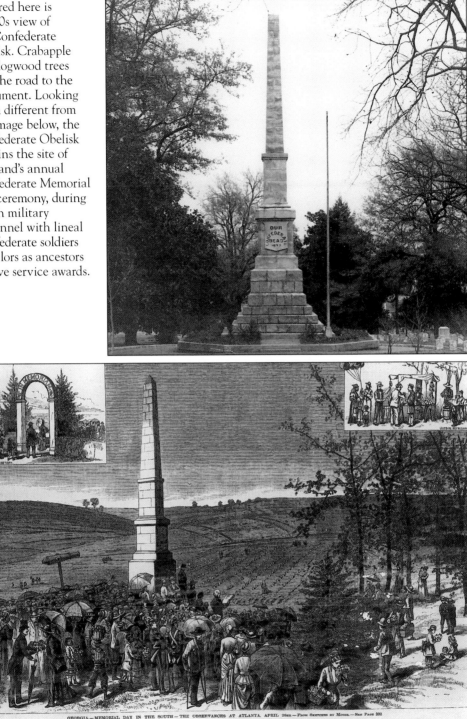

This image of Oakland's Confederate Memorial Day Service was published in 1895 in *Scenes in Oakland Cemetery* by the W.H. Parrish Publishing Company. (Courtesy of Atlanta History Center.)

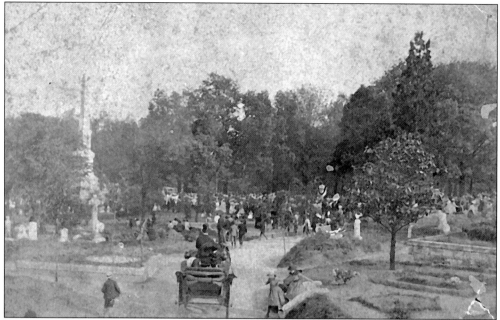

This late-19th-century photograph shows another Confederate Memorial Day celebration. Notice the horse-drawn carriage and the children's clothing. Now, tall oaks tower above the obelisk and the base of the fountain is circular rather than triangular.

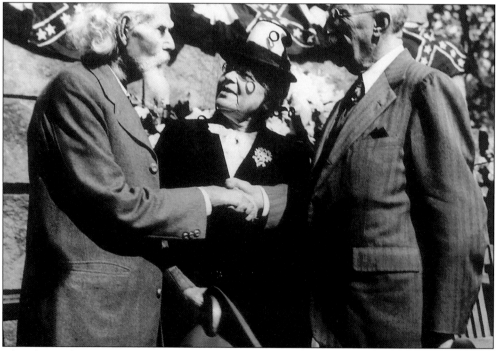

This photograph from the April 26, 1950 Confederate Memorial Day event shows a Confederate veteran shaking hands with guests at the cemetery. Flags are draped across the base of the Confederate Obelisk. If this gentleman was a veteran of the Civil War, he would have to be at least 100 years old.

In 1892, one-fourth of the additional land purchased by the Temple was sold to the Ahavath Achim Congregation. This predominantly Russian group of Jewish immigrants maximized the burial space by eliminating sidewalks within this area. This view of the Ahavath Achim portion of the Jewish sections of the cemetery shows two unknown Confederate soldiers, who were buried when this area was originally designated for Civil War burials.

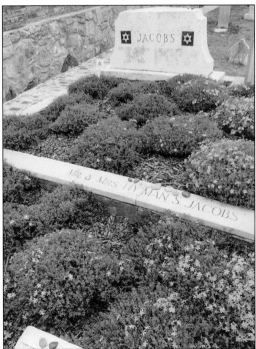

The Temple, formerly known as the Hebrew Benevolent Congregation, purchased land in Oakland in 1878 and 1892 for members of Atlanta's Jewish community. Henry Levi and Jacob Haas were the first Jews to arrive in Atlanta. By 1847, their dry goods store was the largest retail outlet in the city. Shown is the gravesite of Sadie and Hyman Jacobs, just two of the many prominent Atlanta Jews buried within these sections of the cemetery. (Photo by Phillip Lovell, 2001.)

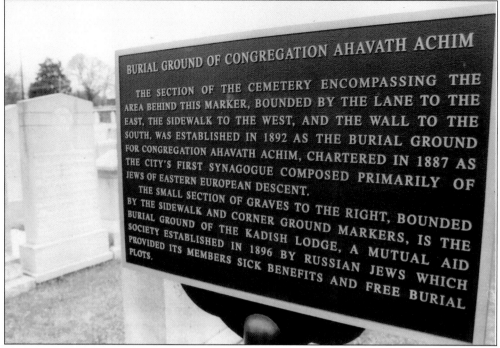

Placed in 2000, this historical marker commemorates the Ahavath Achim area of Oakland. Comprised of Eastern European immigrants, primarily Russian, members of the Ahavath Achim Congregation came to Atlanta after 1885 to join the successful German Jews who formed The Temple. David Mayer was responsible for obtaining the Old Jewish Grounds from the City in 1860. (Photo by Phillip Lovell, 2001.)

The family name—Soloman—is the only word in English on this marker. All of the rest is in Hebrew. At Oakland, older markers were in English, until workers learned to carve letters in Hebrew. The markers tended to be written all in Hebrew. As the Jewish community adapted to life in Atlanta, markers were written in Hebrew on one side and in English on the other. Now most modern Jewish headstones are all in English.

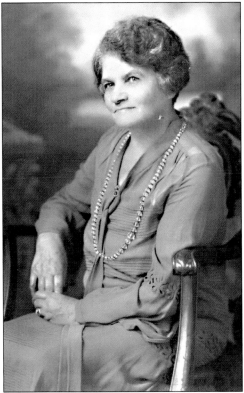

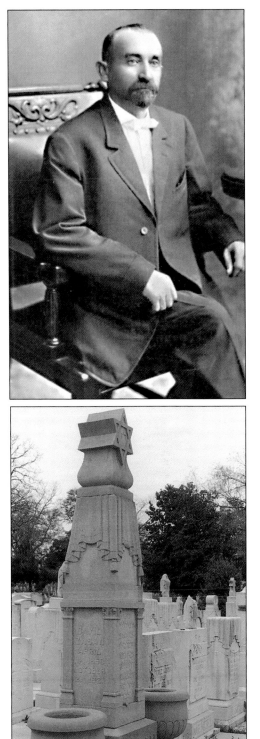

Shown above are historic photographs of Ann E. (1863–1929) and David Zaban (1860–1921). David Zaban served as an early president of Ahavath Achim Congregation. (Courtesy of Erwin Zaban.)

To the right is the distinctive Zaban marker, which features a Magen David, or Star of David. Underneath the star is a veil, a popular Victorian symbol, made to resemble a prayer shawl or tallit.

59

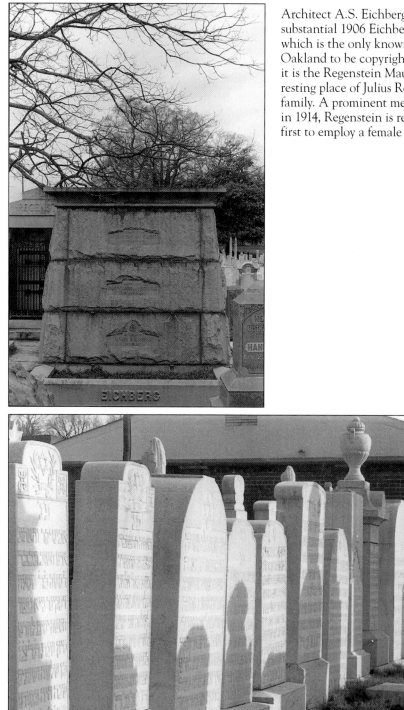

Architect A.S. Eichberg designed the substantial 1906 Eichberg monument, which is the only known marker in Oakland to be copyrighted. Just behind it is the Regenstein Mausoleum, the final resting place of Julius Regenstein and his family. A prominent merchant who died in 1914, Regenstein is remembered as the first to employ a female clerk in the city.

Standing straight and close, these markers are located within the Jewish sections of the cemetery. Many older markers tend to be all in Hebrew. As time has passed, markers in this section have been written entirely in English, except for the traditional Jewish opening, po n'kvar, or "Here Lies," at the top of each stone.

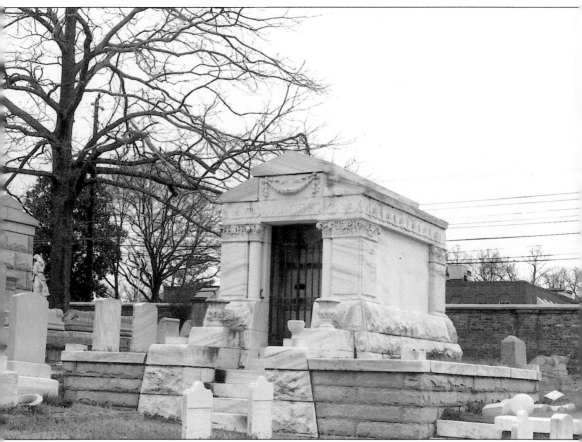

Pictured is the ornate Jacobs Mausoleum. Dr. Joe Jacobs was the founder of the Jacobs drug store chain. In 1886, the first drink of Coca-Cola was sold in his Five Points store by soda jerk Willis Venable (also buried at Oakland) when Venable mixed Dr. Pemberton's syrup with soda water. Dr. Jacobs died in 1929.

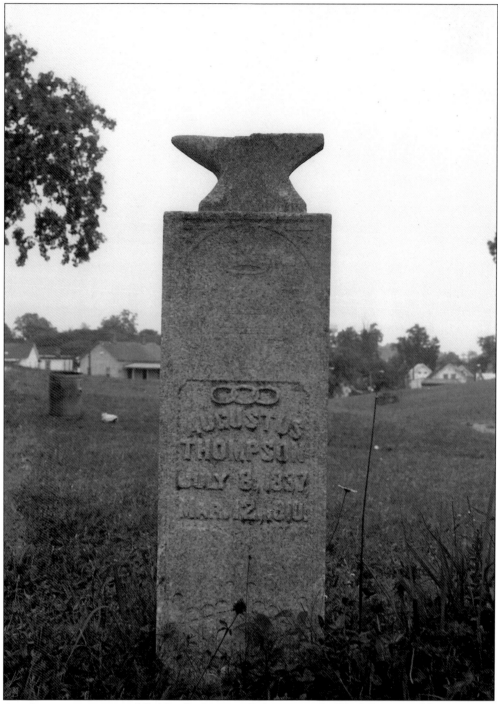

Another important part of Oakland is historically known as the Black Section of the cemetery, established in 1867. Many prominent Atlantans are buried in this section of Oakland. For example, Augustus Thompson (1837–1910) was born a slave in Mississippi and became a blacksmith, represented by the anvil carved into the top of his marker. Mr. Thompson organized the St. James Lodge of African-American Odd Fellows.

Shown at right is a portrait of Carrie Steele Logan (1829–1900) who, in 1889, founded the Carrie Steele Home, Georgia's first orphanage for African-American children. Today, the shelter is known as the Carrie Steele-Pitts Home.

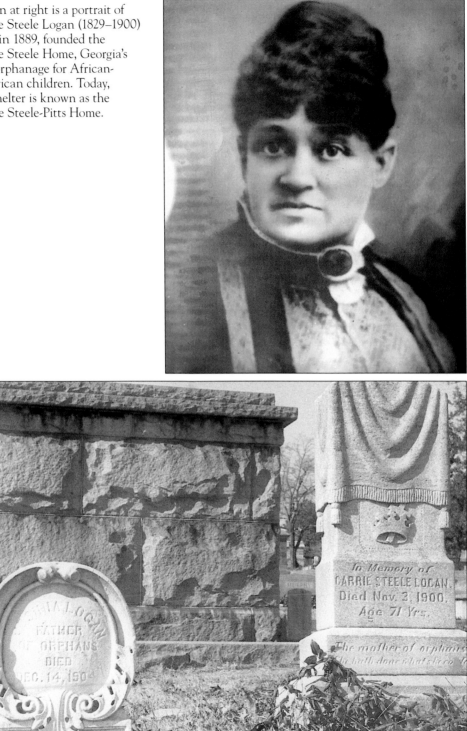

The epitaph on Carrie Steele Logan's marker reads, "The mother of orphans, She hath done what she could." Her husband's marker reads, "Father of Orphans, Died December 14, 1904."

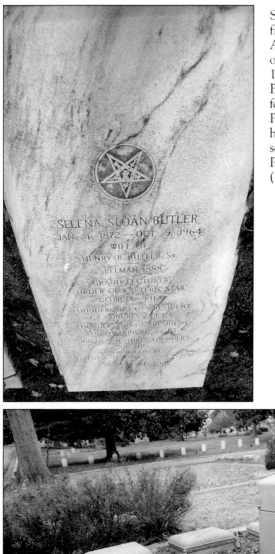

Selena Sloan Butler established the first African-American Parent-Teacher Association in Atlanta in 1911. The organization became statewide in 1919 and nationwide in 1926. In 1970, Butler was named one of the three founders of the now-integrated National PTA. Mrs. Butler died in 1964. Her husband, Henry Rutherford Butler, served as worshipful master of the Prince Hall Masons for many years. (Photo by Phillip Lovell, 2001.)

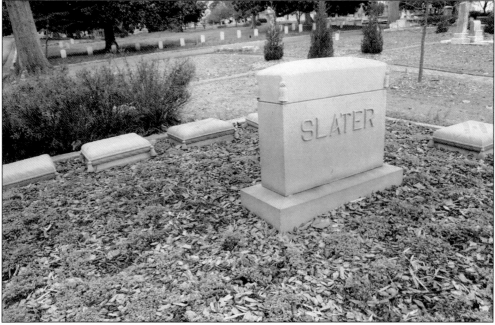

Thomas Heathe Slater (buried at Oakland in 1952) and Henry Butler bought out a drugstore on Auburn Avenue and renamed it the Gate City Drugstore, making it Atlanta's first black-owned pharmacy.

Dr. Roderick D. Badger was a well-known dentist who learned his trade while a slave and was popular with both black and white patients. He died in 1890. The first recorded burial in the Black Section of Oakland was of a slave named Jim on February 10, 1853. He was only 14 when he was interred at Oakland.

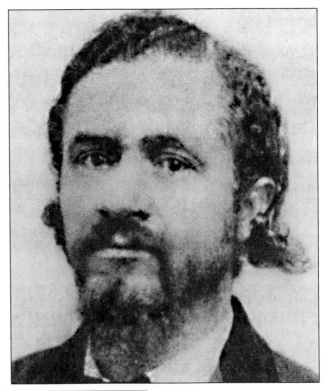

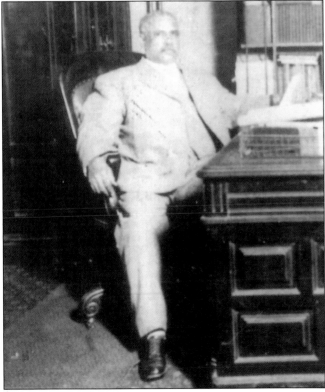

President McKinley named Henry A. Rucker the collector of revenue for the city in 1897, a position he held until 1910. Mr. Rucker served as president of Georgia Real Estate Loan and Trust Company, one of two black-owned financial institutions in Atlanta at the time. He died in 1924.

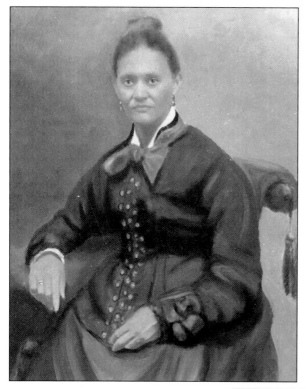

One of Atlanta's most interesting families buried within the Black Section is the Graves family. Born a slave in 1830, Sinai Calhoun Webb Murray was the biracial daughter of Judge William Ezzard and Nellie Calhoun. Sinai served as the housekeeper and nursemaid for Dr. Andrew Bonaparte Calhoun and received a piece of Atlanta property upon his death. She was the mother of Catherine Webb Graves. (Courtesy of Harriet N. Chisholm.)

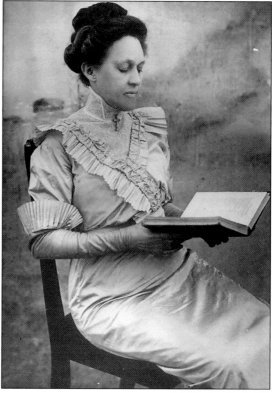

Catherine Webb Graves was born in Newnan, Georgia, on the Calhoun Plantation and attended Atlanta University. She married Antoine Graves and had five children: Catherine, Marie, Helen, Lena, and Antoine Jr. Here, Mrs. Graves poses with a book, which signifies that she was educated and could read, representing her place in Atlanta's elite black society. (Courtesy of Harriet N. Chisholm.)

The Graves family legacy continues at Oakland. This historic photograph shows Antoine Graves, a prominent Atlanta realtor and the husband of Catherine Webb. The only mausoleum in the Black Section was built upon his death in 1941. Mr. Graves also served as the first principal of Gate City Public School from 1884 to 1886. (Courtesy of Harriet N. Chisholm.)

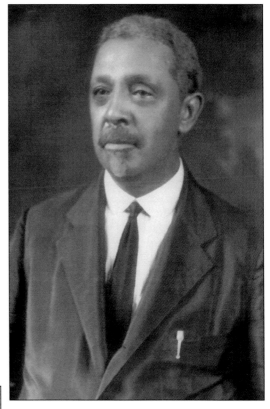

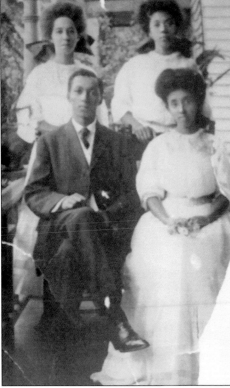

Antoine and Catherine Graves had six children. The surviving children, pictured here, are, from left to right, (front row) Antoine Jr. and Nellie; (back row) Catherine and Marie. All four children attended college. Marie married Dr. Nash, who served as a surgeon during World War II and is buried at Southview Cemetery in Atlanta. Marie was buried at Oakland in 1984. (Courtesy of Harriet N. Chisholm.)

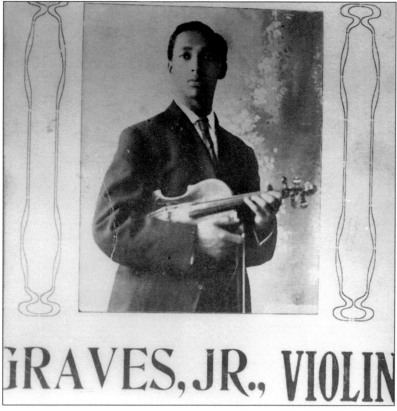

GRAVES, JR., VIOLIN

A talented concert violinist, Antoine Graves Jr. traveled throughout Georgia in 1908 performing for "whites only" audiences. He received rave reviews in the newspapers of the time. (Courtesy of Harriet N. Chisholm.)

A dentist by trade, Antoine Graves Jr. graduated from Howard University in 1912 and set up his practice at 502 Auburn Avenue in downtown Atlanta. He was nicknamed "Judge" by his family. (Courtesy of Harriet N. Chisholm.)

Pictured at right is Lena Louise Graves, who died in 1899 when she was only nine months old. Her cause of death is listed as laryngitis. Her cousin, the entertainer Lena Horne, was named in her honor. Lena's sister, Helen Lamar, died of pneumonia at age two and was buried at Oakland in 1898. (Courtesy of Harriet N. Chisholm.)

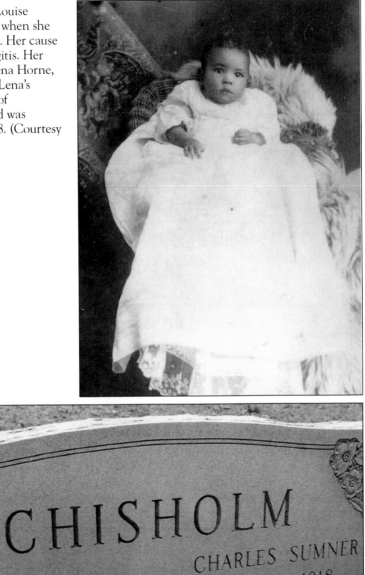

Dr. Charles Sumner Chisholm, an optometrist, was married to Harriett Nash Chisholm. Dr. Chisholm came to rest at Oakland in 1986 at the age of 68. (Photo by Phillip Lovell, 2001.)

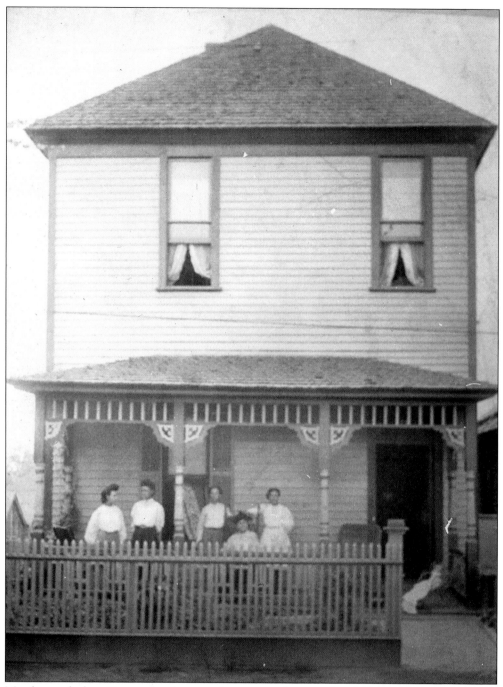

Members of the Graves family are shown on the porch of their home, located at 116 Howell Street. This house still stands and is owned by the National Park Service as part of the Martin Luther King Jr. Historic District. (Courtesy of Harriet N. Chisholm.)

Four

NOTABLE PEOPLE

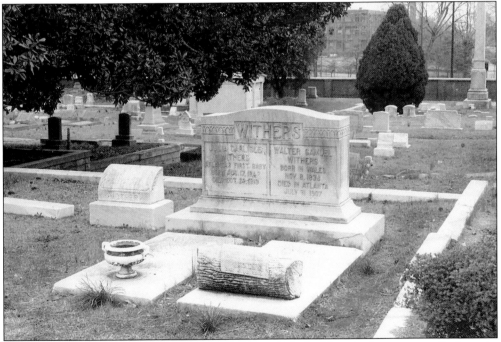

Julia Carlisle Withers is known as "Atlanta's First Baby," although she was actually born in 1842 when Atlanta was known as Terminus. Her father, Willis Carlisle, served as an original commissioner of Marthasville from 1843 to 1844 and also served as chief marshal. Julia's husband, Walter S. Withers, owned Withers' Foundry and died in 1907. The shortened tree trunk at the end of his grave symbolizes a life cut short or goals left unfulfilled.

In 1848, Moses Formwalt served as Atlanta's first mayor. A tin and coppersmith, he was the only mayor to die as the victim of a homicide; he was killed in 1852. Originally buried on the James Bell family lot, his remains were moved to the fountain and the City dedicated this large monument in his honor on May 26, 1916.

Dr. Benjamin F. Bomar served as Atlanta's second mayor in 1849. He also served as the first clerk of the Fulton County Superior Court from 1854 to 1856. Buried in 1868, his family lot is located in the Original Six Acres.

James M. Calhoun served as mayor of Atlanta from 1862 to 1865. He had the dubious honor of surrendering the city to the Union Army. On September 2, 1864, Mayor Calhoun and a committee of citizens went to the Federal camp and agreed to surrender the city in exchange for protection of property and non-military citizens. The city was destroyed anyway.

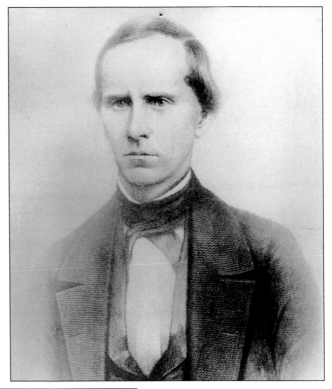

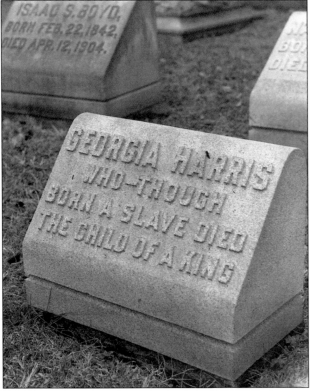

Georgia Harris, "who though born a slave died the child of a King," was buried on the Boyd family lot in 1920. This was controversial because the Boyds were white and Ms. Harris died during the era of segregation. The mayor and each family who owned cemetery property surrounding the Boyd's lot had to consent before the city allowed the burial.

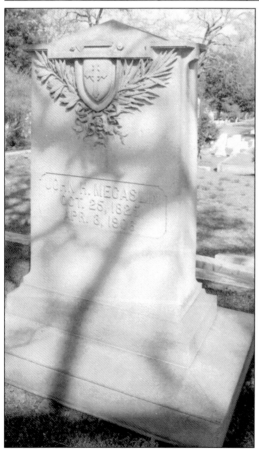

Maj. John H. Mecaslin was elected city treasurer in 1862 and served throughout the Civil War. This ledger sheet shows that on July 1, 1864, Major Mecaslin left $1.64 in Confederate money in the City of Atlanta's treasury. (Courtesy of Charles and Sylvia Harrison.)

Major Mecaslin was also a member of the city council and served as chief of the volunteer fire department, Station #1. From 1897 to 1904, he was president of Atlanta Gas Light Company. (Photo by Phillip Lovell, 2001.)

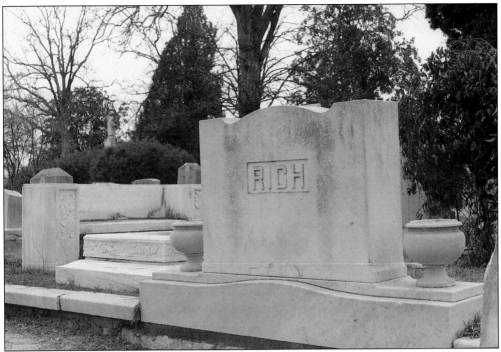

An immigrant of Hungary, Morris Rich founded the Rich's Department Store chain. His brothers, Emanuel and Daniel, assisted with the operation of the store. All three brothers are buried in the Jewish sections at Oakland. Morris died in 1928. Emanuel was buried in 1897, and Daniel died in 1920.

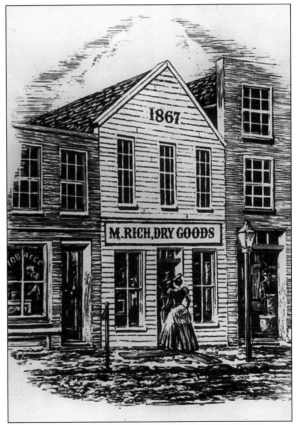

This woodcutting illustrates the original 1867 storefront of the M. Rich dry goods store, located on Whitehall Street in downtown Atlanta. The 1880s Rich's store featured the first plate-glass window and elevator in the southeast. During the Great Depression, Coca-Cola and Rich's paid the salaries of the teachers and police officers. (Courtesy of Atlanta History Center.)

Joseph Emerson Brown served Georgia well until his death in 1894. He was governor from 1857 to 1865, chief justice of Georgia from 1868 to 1870, and a United State senator from 1880 to 1891. In addition, he served as president of the Western & Atlantic Railroad from 1870 to 1890.

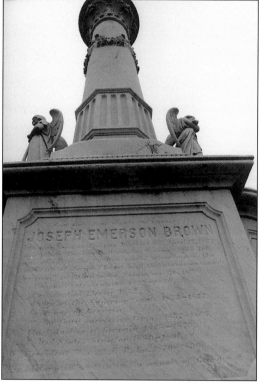

As befitting a man of his service, Governor Brown's outstanding marker features a huge column with a pair of figures holding down-turned torches, representing death or a life snuffed-out. The detailed inscription on his monument tells of his many achievements. (Photo by Phillip Lovell, 2001.)

Elizabeth Grisham Brown, wife of Gov. Joseph E. Brown and mother of Gov. Joseph M. Brown, was an assertive woman for her time. She is the only woman featured in the statuary on the Georgia State Capitol grounds. She is sitting in a chair with her husband standing behind her for his official statue. While she was alive, she traveled to Italy and had this Rococo-style marker carved with her likeness and shipped home to Georgia.

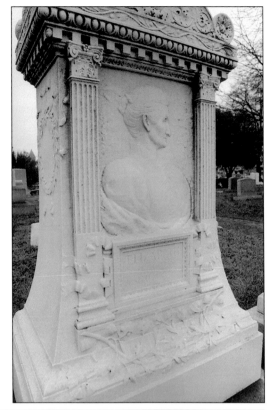

Known as "Little Joe Brown," Joseph Mackey Brown served as Georgia's governor from 1909 to 1911 and from 1912 to 1913. A graduate of Oglethorpe University, he attended Harvard Law School after he had passed the bar and left due to severe eyestrain. He served 23 years at the Western & Atlantic Railroad, then moved back to Cherokee County. He was buried beside his parents in March 1932. (Photo by Phillip Lovell, 2001.)

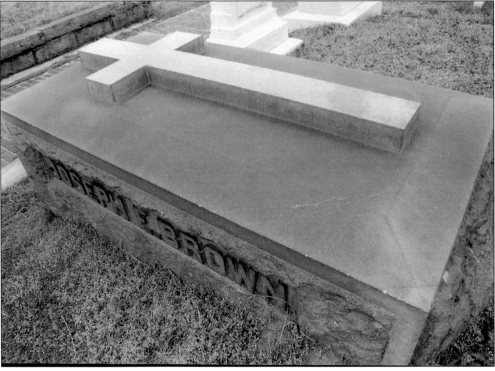

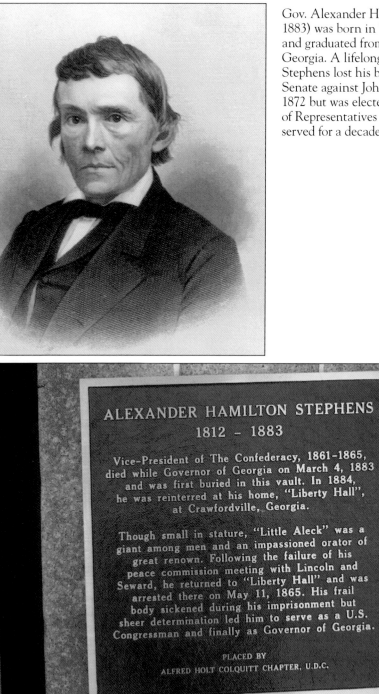

Gov. Alexander H. Stephens (1812–1883) was born in Wilkes County and graduated from the University of Georgia. A lifelong public servant, Stephens lost his bid for the U.S. Senate against John B. Gordon in 1872 but was elected to the U.S. House of Representatives that same year and served for a decade.

ALEXANDER HAMILTON STEPHENS
1812 – 1883

Vice-President of The Confederacy, 1861–1865, died while Governor of Georgia on March 4, 1883 and was first buried in this vault. In 1884, he was reinterred at his home, "Liberty Hall", at Crawfordville, Georgia.

Though small in stature, "Little Aleck" was a giant among men and an impassioned orator of great renown. Following the failure of his peace commission meeting with Lincoln and Seward, he returned to "Liberty Hall" and was arrested there on May 11, 1865. His frail body sickened during his imprisonment but sheer determination led him to serve as a U.S. Congressman and finally as Governor of Georgia.

PLACED BY
ALFRED HOLT COLQUITT CHAPTER, U.D.C.

Many of Oakland's famous residents have plaques placed at their gravesites. Stephens was temporarily interred in the Cotting-Burke Vault until his final resting site at Liberty Hall in Crawfordville, Georgia was prepared. Stephens and Commandant J.F. Burke of Gate City, the owner of the vault, were good friends. According to newspaper accounts, more than 20,000 people came to Oakland for the service.

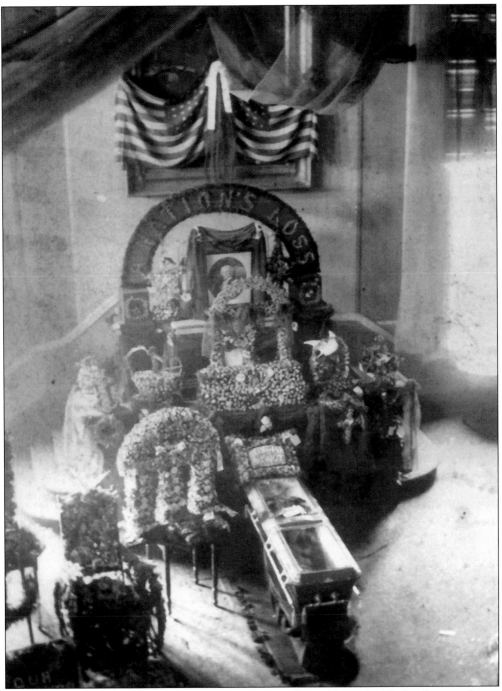

In this March 1883 photograph, the body of Georgia hero Alexander H. Stephens is shown while lying in state in the Senate Chamber of the Georgia State Capitol. Stephens served as vice president of the Confederacy, a U.S. Congressman from 1872 to 1882, and governor of Georgia from 1882 to 1883. Often ill, he took a trip to Savannah to celebrate the state's 150th anniversary which reputedly led to his death. (Courtesy of Georgia Department of Archives and History.)

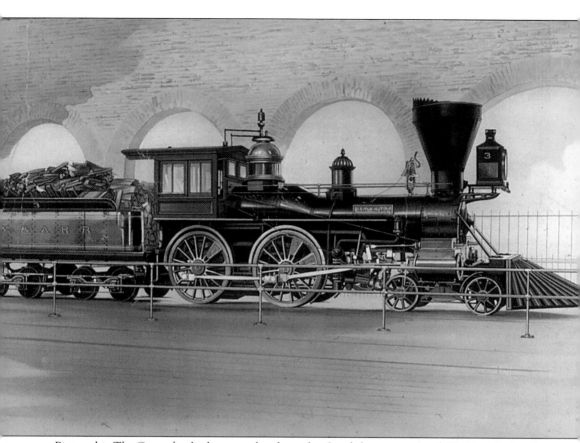

Pictured is *The General,* which was stolen from the Confederates on April 12, 1862 during the Great Train Chase. *The General,* a tender, and three boxcars were stolen by Federal soldiers in disguise from Big Shanty, now known as Kennesaw. As the raiders raced toward Chattanooga, attempting to destroy bridges and cut off a vital Western & Atlantic railroad supply line, Capt. William Fuller and crew captured them after a 90-mile chase on foot and by several locomotives, including *The Texas, The Yonah,* and *The William R. Smith.* Engineer Jefferson Cain was buried in Oakland in 1897.

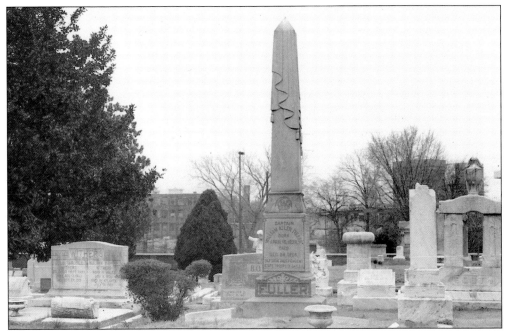

Capt. William Fuller's marker, located in the northwestern corner of the cemetery, shows an obelisk draped by a pall or veil. The obelisk symbolizes resurrection and the pall represents sorrow or mourning. The story of the Great Train Chase is carved into the side of Captain Fuller's monument.

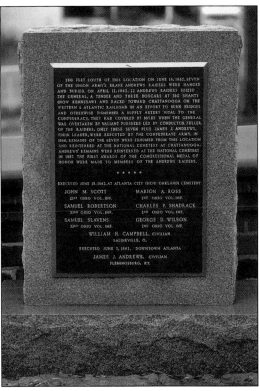

This Oakland monument commemorates eight of the men known as "Andrews' Raiders" and executed as spies by the Confederate Army in June 1862. James Andrews was executed in downtown Atlanta on June 7, 1862. Seven others were hanged at the cemetery on June 18, 1862. All of the Raiders remains were exhumed in 1866–1867 and reinterred at the National Cemetery in Chattanooga. Eight members of Andrews' Raiders were the first recipients of the Congressional Medal of Honor.

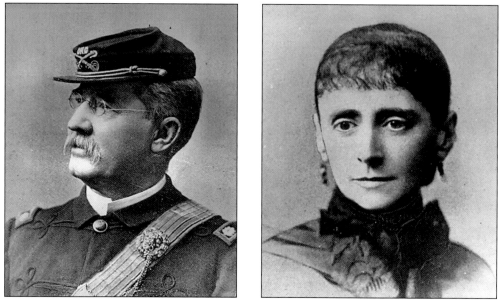

Pictured at right is Fanny C. Milledge, who died in April 1895 at age 51. She and her husband, Col. John Milledge, at left, are buried within the Atlanta Ladies Memorial Association section of the cemetery. During Mrs. Milledge's tenure with the United Daughters of the Confederacy, marble headstones were installed in the Confederate section. Colonel Milledge died in February 1899 and was a noted lawyer and Confederate officer. His grandfather, John Milledge, served as the governor of Georgia from 1802 to 1806. The Lion of Atlanta was inspired by a concept submitted by Colonel Milledge to the Atlanta Ladies Memorial Association.

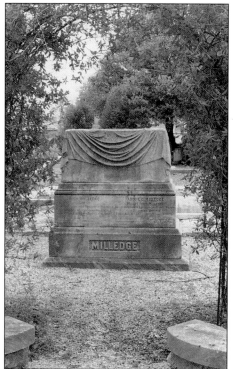

The large monument for the Milledges is draped with a veil, representing sorrow. A garden trellis frames the entrance to the Milledge monument, which is sited on the hill near Generals' Corner, where the grave of Gen. Alfred Iverson is located (1829–1911). Though wounded during the Seven Days Battle, General Iverson fought in the battles of Stone Mountain, Sharpsburg, Chancellorsville, and Gettysburg.

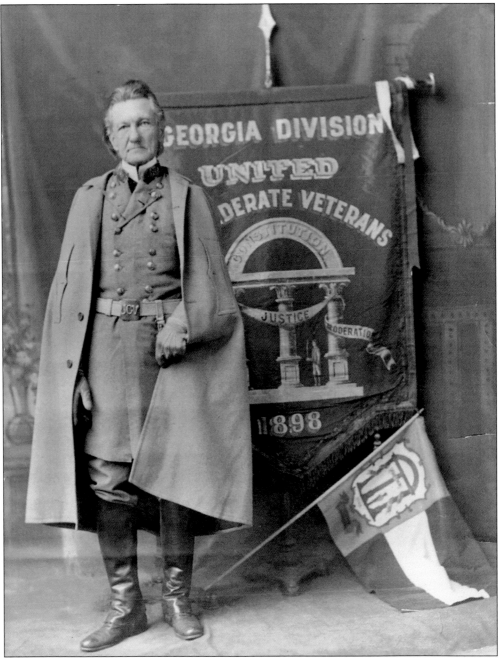

Clement Anselm Evans (1833–1911) was a Confederate brigadier general during the Civil War. Born in Stewart County, Georgia, he was commissioned as a major in Company E, 31st Georgia Infantry. He participated in almost all the battles of the Virginia Campaign and surrendered under General Lee at Appomattox. Later, General Evans became a well-respected Methodist minister and wrote *Military History of Georgia* and served as editor of the 13-volume *Confederate Military History*. General Evans came to rest in Oakland in 1911.

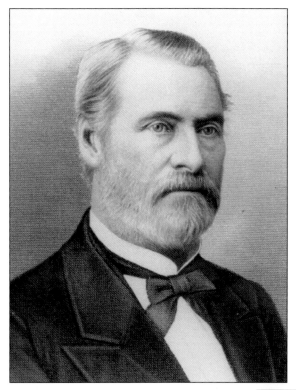

Gen. Alfred Austell founded the Atlanta National Bank with $200,000 in capital following his service during the Civil War. Later known as First National Bank of Atlanta, it is called Wachovia Bank today. He also served as a director of the Western & Atlantic Railroad. General Austell is interred inside the magnificent Austell-Kennedy-Thornton Mausoleum.

Pictured at right is the grave of Gen. William Walker (1822–1899). General Walker served as the Fulton County tax collector. In 1871, he started a fire insurance company with Capt. Issac S. Boyd. In 1876, they joined the British American Insurance Company of Canada and were underwriting fire insurance in 11 states. His grave is in Block 319, Lot 1.

John Brown Gordon (1832–1911) began his soldiering career as captain of the "Raccoon Roughs." Ordered to the battlefront in Virginia, he quickly rose to the rank of brigadier general in the Confederate Army. In May 1864, he became a major general. Elected to the U.S. Senate in 1873, he defeated Alexander H. Stephens and Benjamin Harvey Hill, both of whom are buried at Oakland. Gordon also served as president of the Louisville and Nashville Railroad.

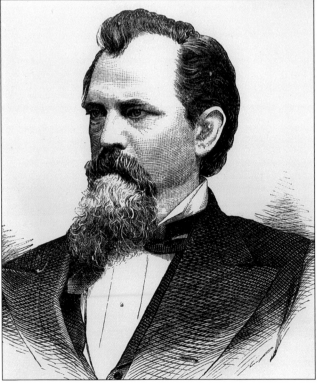

Called the "Idol of Georgians" by biographer James F. Cook, John B. Gordon served as governor of Georgia from 1886 to 1890. During his two terms of office, he is remembered for reducing the state's debt and holding down taxes. Under his tenure, the city hosted the Piedmont Exposition and completed the State Capitol.

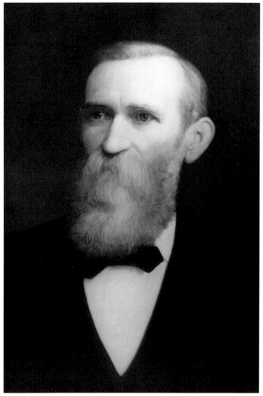

This picture of William Jonathan Northen, Georgia's governor from 1890 to 1894, hangs in the Bell Tower Building at Oakland. He attended Mercer University and opened a school near Mount Zion in Sparta, Georgia. He resumed teaching after the Civil War, but retired due to poor health in 1874. A successful farmer, he served as president of the Georgia State Agricultural Society from 1886 to 1890. After serving three terms on the state legislature, he was governor for two terms, where he made many changes regarding education and commerce. He was buried at Oakland in 1913.

Born in 1821, Lucius J. Gartrell served as a Confederate brigadier general during the Civil War and represented Georgia in the U.S. Congress before the Civil War and in the Confederate Congress. Known as a well-spoken criminal attorney, he died in 1891 and is buried in Block 47, Lot 2, west of the Bell Tower Building.

The impressive Lochrane/Rudolph family lot serves as the final resting place for Judge Osborne Lochrane, an Irish immigrant who became a noted orator and Georgia Supreme Court justice. The lot features a beautiful painted settee in the Gothic style. Judge Lochrane's tall monument features a tall column and garland.

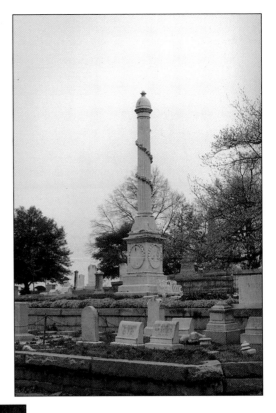

LAND OF MY ADOPTION WHERE THE LOVED SLEEP FOLDED IN THE EMBRACE OF YOUR FLOWERS, WOULD THAT IT WERE MY DESTINY TO INCREASE THE FLOOD TIDE OF YOUR GLORY AS IT HAS BEEN MINE TO SHARE YOUR FORTUNES: FOR WHEN MY YEARS TREMBLE TO THEIR CLOSE, I WOULD SLEEP BENEATH YOUR SOIL WHERE THE DRIP OF APRIL TEARS MAY FALL UPON MY GRAVE; AND THE SUNSHINE OF YOUR SKIES WARM SOUTHERN FLOWERS TO BLOOM UPON MY BREAST.

A close-up of Judge Lochrane's epitaph shows the regard he held for his adopted homeland. Part of it reads, "Would that it were my destiny to increase the flood tide of your glory as it has been mine to share your fortunes . . . I would sleep beneath your soil where the drip of April tears may fall upon my grave." (Photo by Phillip Lovell, 2001.)

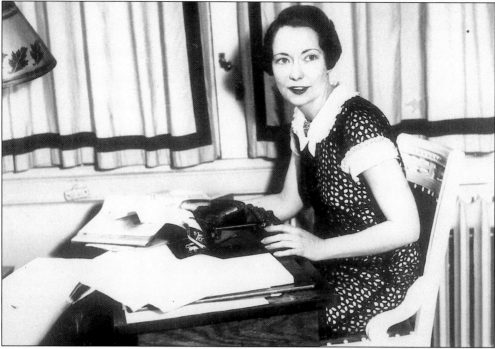

Gone with the Wind author Margaret Mitchell Marsh was said to be fond of Oakland and brought many of her guests to the cemetery. Thousands of visitors come to her family plot annually to pay their respects. (Courtesy of Margaret Mitchell House & Museum/Atlanta History Center.)

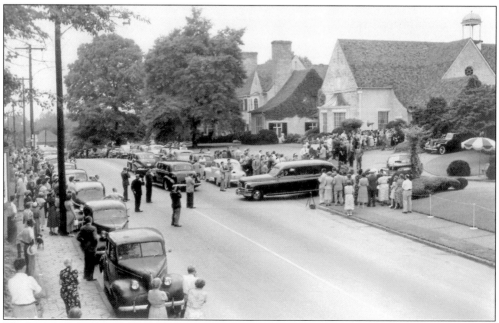

The hearse carrying Marsh's body is shown leaving Springhill Funeral Home on August 17, 1949. Born in 1900, Marsh died after she was struck by a taxi while crossing Peachtree Street. (Photo by Frank Tuggle; courtesy of *Atlanta Journal-Constitution*.)

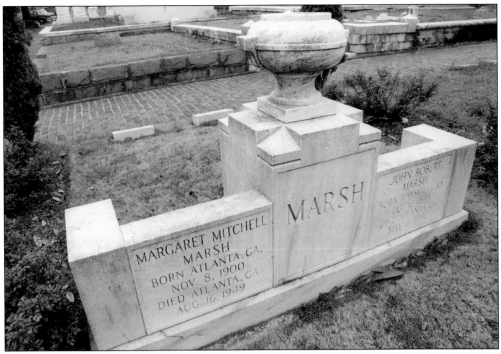

The Mitchell family plot serves as the final resting place for Margaret and her husband, John Marsh, as well as for Margaret's parents, Eugene and Maybelle Mitchell. Both Eugene and his son Stephens served as president of the Atlanta Historical Society. After the publication of *Gone with the Wind*, Stephens Mitchell spent most of his law career protecting the book against copyright infringements.

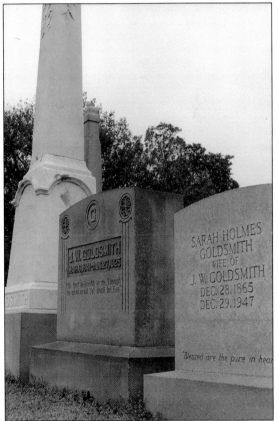

The Goldsmith family is one of Atlanta's oldest and is well represented at Oakland. Pictured here are the markers for Jeremiah W. Goldsmith and his wife, Sarah Holmes. Mr. Goldsmith, who died in 1925, was a well-known banker, merchant, and property owner. Their son, known as "Wick," was president of the Goldsmith-Grant automobile distributing company and served as president of the Capitol City Club in 1920.

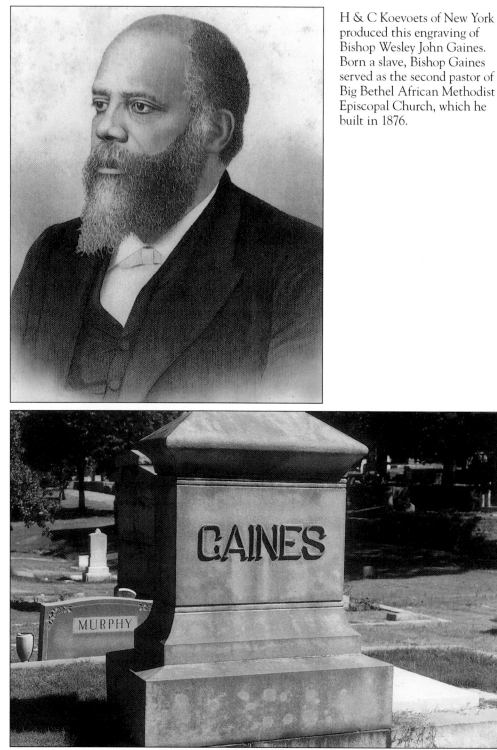

H & C Koevoets of New York produced this engraving of Bishop Wesley John Gaines. Born a slave, Bishop Gaines served as the second pastor of Big Bethel African Methodist Episcopal Church, which he built in 1876.

Bishop Gaines was also a founder of Atlanta's Morris Brown College in 1881, when the college began in the basement of Big Bethel Church. He died in 1912.

Sitting on the marble coping is Francis Marion Stocks, the father of lot owner Thomas F. Stocks. This photograph was probably taken following the funeral of Mrs. Diamond Edwards Stocks in January 1913. (Courtesy of Stocks family.)

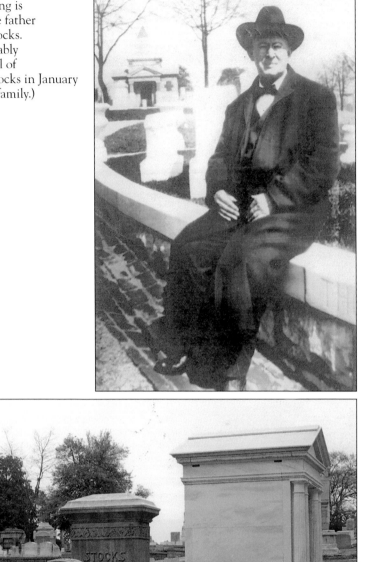

The lot owned by Francis Stocks is located west of the Thomas F. Stocks lot. This modern photograph of the F.M. Stocks lot features a beautiful granite wall with marble coping. Notice that the new markers for the Weatherly members of the family have flowers carved into the stone that are similar to those in the older markers.

This photograph of Blanche, John Henry, and Alice Galhouse was taken on June 6, 1896 at the Hudson Studio on Whitehall Street. John Henry was buried on the family lot in April 1919. His son, John Henry Galhouse Jr., died when he was just four days old in October of 1916. (Courtesy of Rick Wolfarth.)

The inscription on the back of the photograph below of Henry and Agnes Galhouse reads, "Father & Mother - just picked basket of roses to take to the cemetery." The Galhouses once owned a nursery in Dayton, Ohio. In 1886, they moved to Griffin, Georgia, and started another nursery, then moved to Atlanta and lived at 310 McDonough Boulevard Southeast. They are both buried at Oakland. (Courtesy of Rick Wolfarth.)

Selena Sloan Butler was an African-American woman who was well known for her generous contributions to education. She died in 1964, prior to being acknowledged as one of the three founders of the National Parent-Teacher Association.

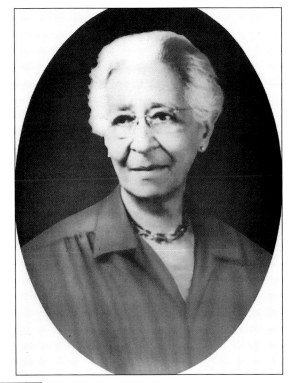

Samuel Martin Inman (1843–1915) was one of Atlanta's movers and shakers. A successful cotton merchant, Mr. Inman and Joel Hurt formed the East Atlanta Land Company and developed Inman Park, Atlanta's first suburb (now a successful in-town neighborhood). His first wife, Jennie D., died on July 3, 1890. His second wife, Mildred, passed away on December 28, 1946.

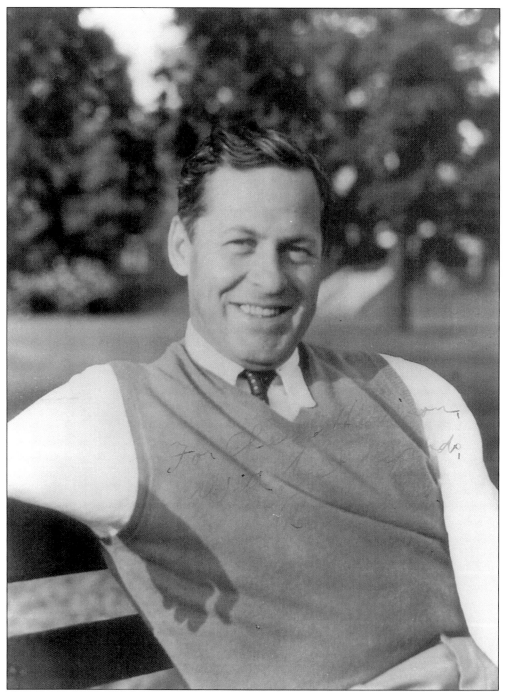

Known as the greatest amateur golfer of all time, Robert Tyre Jones was the first player to win the "Grand Slam" of golf. In 1930, he won four major tournaments in one year: the U.S. Open, the U.S. Amateur, the British Open, and the British Amateur. After retiring from tournament play, Bobby Jones founded the Augusta National Golf Club and the Masters Tournament. Many people do not realize that Mr. Jones was an attorney as well as an athlete. (Courtesy of Charles and Sylvia Harrison.)

Native Atlantan Bobby Jones is shown presenting a trophy to 14-year-old Charles Harrison during a 1946 golf tournament at the Atlanta Athletic Club. The trophy was awarded for "outstanding athleticism." Mr. Harrison is a trustee of the Historic Oakland Foundation. (Courtesy of Charles and Sylvia Harrison.)

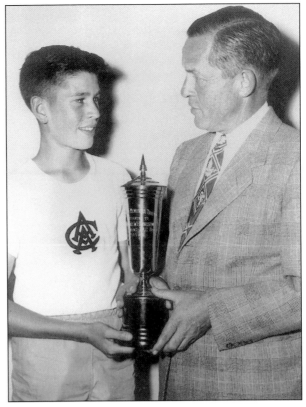

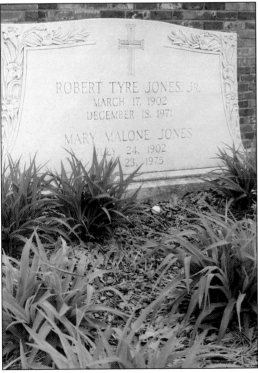

Eighteen plants representing the eighteen holes at Augusta National have been placed in a horseshoe near Bobby Jones's grave. Bobby Jones, who was born on St. Patrick's Day in 1902 and died on December 18, 1971, is buried beside his wife, Mary Malone Jones (1902–1975). The Malone family lot is located against the wall along Memorial Drive. Many visitors leave golf balls at Bobby Jones's grave as a tribute to him. (Photo by Phillip Lovell, 2001.)

Sadly, one of Oakland's newest markers is for Franklin Miller Garrett, Atlanta's official historian and beloved trustee of Historic Oakland Foundation. Beginning in the 1930s, Mr. Garrett spent years recording burial information at the cemetery and learning and sharing the history of Atlanta. Born on September 25, 1906, he died on March 5, 2000 at age 93.

Five

ART AND SYMBOLISM

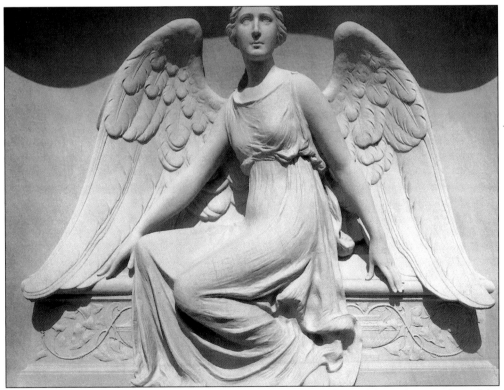

Placed in honor of Mary Glover Thurman by her nephew, this beautiful angel is a replica of the Kinsley Monument in Woodlawn Cemetery in New York, which was carved by Daniel Chester French. Mrs. Thurman's house and garden were once located on the current site of the Biltmore Hotel. She became known as "The Angel" because of her frequent visits and flower deliveries to local hospitals.

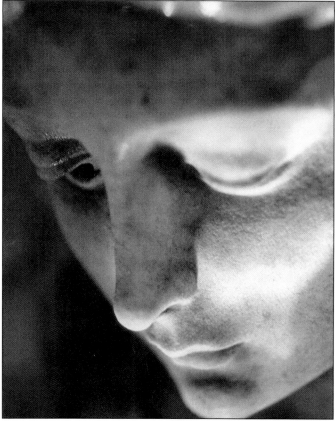

This modern photograph shows a close-up of the historic angel statue shown below. Her eyelids, nose, and chin are quite distinctive. The intricate detail found carved on many of Oakland's markers is outstanding. (Photo by R. Shane Garner.)

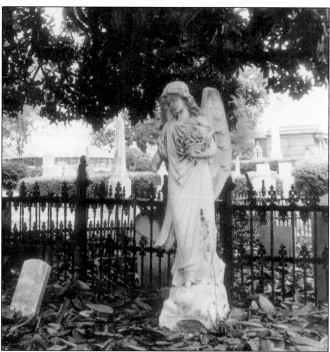

Sheltered beneath a huge magnolia tree, this angel is located in the northern quadrant of the cemetery. Oakland is full of Victorian symbolism, including this basket of lilies, which represent purity or innocence. The cemetery is often considered "Heaven on Earth" and serves as a bridge between the living and the dead.

Designed in the Neo-classical style, the Neal Mother and Daughter monument features both women dressed in flowing Greek or Roman robes. The wreath symbolizes eternity and the palm branch indicates spiritual victory over death. The open book represents knowledge learned on earth, while the closed book symbolizes what can only be learned in heaven. The figures are seated in front of a Celtic cross.

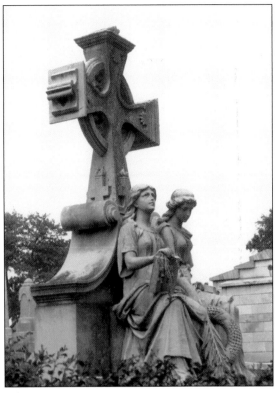

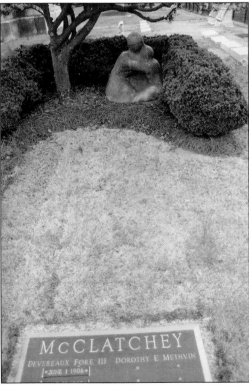

The McClatchey lot is partially bordered by a boxwood hedge, which surrounds a freeform statue of a mother and child. Evergreen plants traditionally represent life. The dogwood stands for the Atonement. (Photo by Phillip Lovell, 2001.)

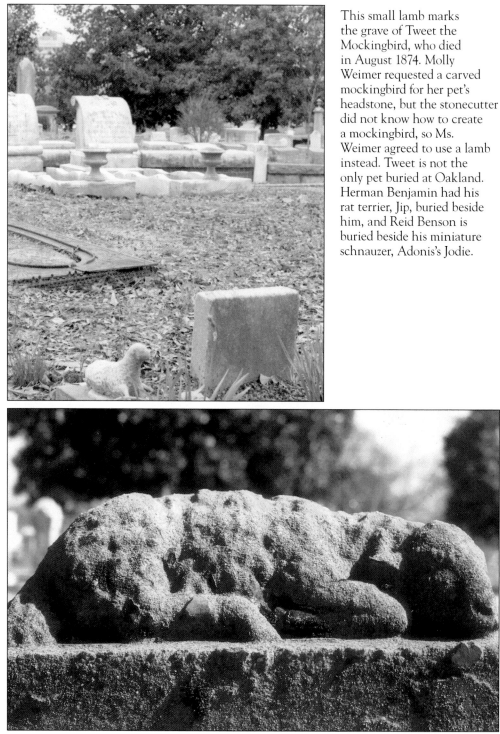

This small lamb marks the grave of Tweet the Mockingbird, who died in August 1874. Molly Weimer requested a carved mockingbird for her pet's headstone, but the stonecutter did not know how to create a mockingbird, so Ms. Weimer agreed to use a lamb instead. Tweet is not the only pet buried at Oakland. Herman Benjamin had his rat terrier, Jip, buried beside him, and Reid Benson is buried beside his miniature schnauzer, Adonis's Jodie.

A much larger lamb rests on the top of this child's grave, representing the Lamb of God. Lambs traditionally mark children's graves. The sleeping animal corresponds to the sleeping child, denoting a temporary separation until the family is reunited in heaven.

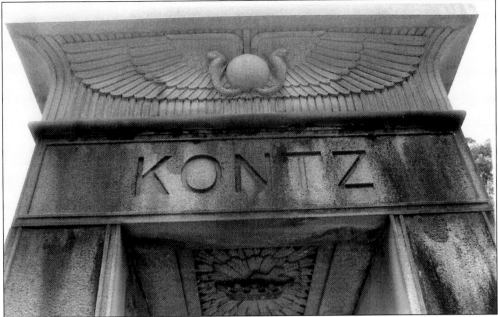

The Kontz monument is one of Oakland's few examples of Egyptian Revival style. At the top of the marker is the winged Egyptian sun god, Ra. This pagan style also features Christian designs, such as the cross and crown carved into the ceiling of the monument.

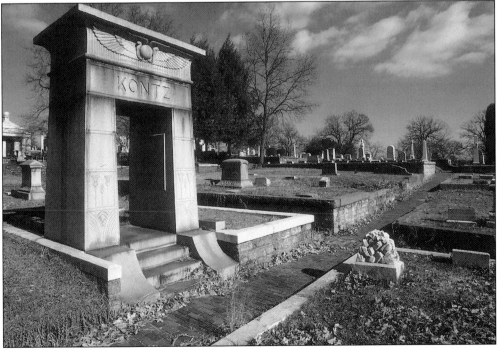

Lotus leaves are carved into the sides of the marker, representing the renewal of life. Christian Kontz was a German-born immigrant to Atlanta. His home once stood on the site of the *Atlanta Journal-Constitution*. He died in 1881. The small marker on the right appears to be a pile of rocks. This marker represents a life built on a firm religious foundation.

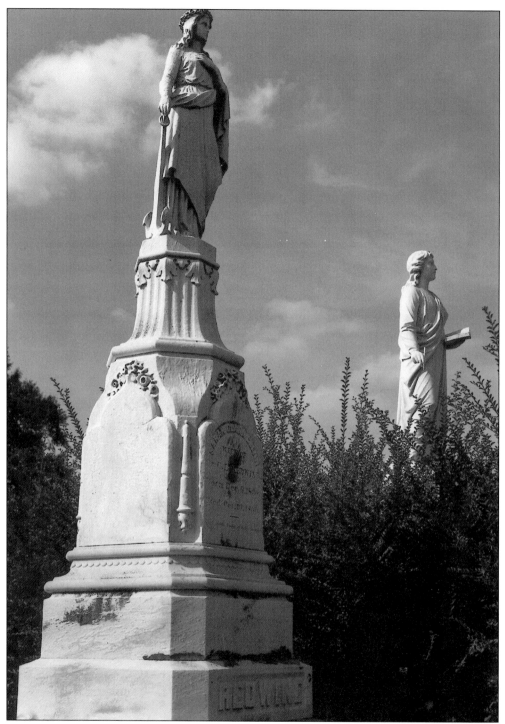

A historic privet hedge separates the Redwine and Shedden angels. The anchor held by the Redwine angel stands for hope and her wreath is for eternity or memory. The Shedden angel is writing down the accomplishments of the deceased. Flowers represent the shortness of life and are often found carved into markers. Roses are for love and Calla lilies are for sympathy.

Shown is a replica of the End of the Trail sculpture as a beautifully carved image on the marker of Ben F. Perry Jr. (1883–1933). James Earle Fraser conceived his famous sculpture because of the many interactions he had with the Sioux Indians while he was growing up in South Dakota. He felt the Indians had been treated unfairly and suffered greatly at the hands of the white man. Fraser is primarily known for two famous works: the model for the Indian head-Buffalo nickel, originally issued in 1913, and the End of the Trail sculpture, which was displayed for the Panama Pacific Exposition in San Francisco in 1915 and became one of the most familiar sculptures of the American West.

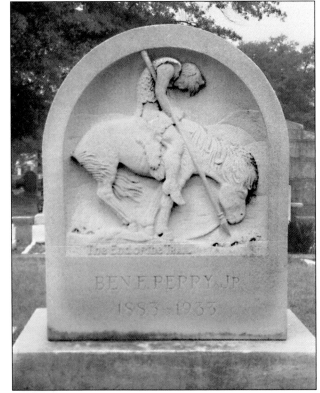

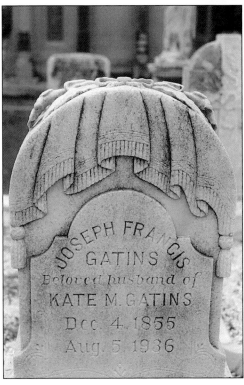

This marker for Joseph Francis Gatins (1855–1936) is covered with a pall or veil, which represents sorrow. Across the top of the marker is a spray of lilies carved into the marble. The lilies represent innocence or purity. Flowers with broken stems represent premature death or an interrupted life.

The angels on Gov. Joe Brown's monument are looking downward, toward the person who is coming up to heaven. The torches represent a life snuffed out, and the column is for life.

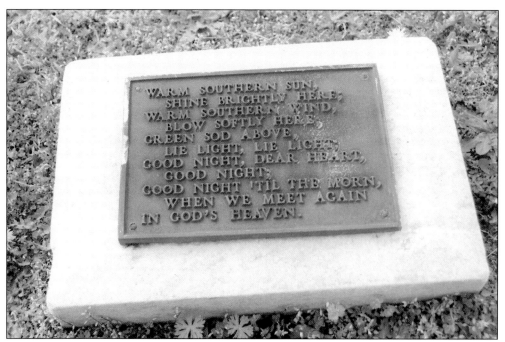

Fascinating epitaphs abound at Oakland. This one states, "Warm southern sun, Shine brightly here; Warm southern wind, Blow softly here, Green sod above, Lie light, lie light; Good night, dear heart, Good night; Good night 'til the morn, When we meet again in God's heaven."

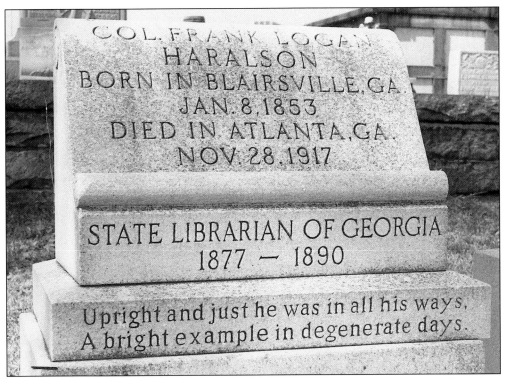

The scroll-style marker above tells the story, in brief, of Col. Frank Logan Haralson. Often markers show that people were born elsewhere and moved to the city. Colonel Haralson was born in Blairsville, Georgia, and died in Atlanta. He served as state librarian from 1877 to 1890. His epitaph reads, "Upright and just he was in all his ways, A bright example in degenerate days."

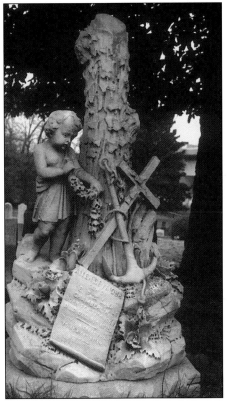

Eddie Kiser was only 17 when he died and his marker abounds with symbolism. The short tree trunk shows a life cut short, with ivy for abiding memory and eternal friendship. The anchor represents hope, and the scroll tells the story of his short life. The rock base shows that his life was built on a firm religious foundation.

This sunflower shown on one of the Marsh urns represents prosperity, as do cedar trees. Other botanical symbols commonly found within Oakland are daffodils (regards), daisies (innocence or hope), marigolds (grief or sorrow), and rosemary (remembrance).

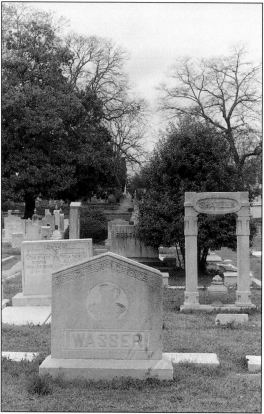

Oakland's Jewish sections are rich with symbols. The pitcher and basin carved on the Wasser monument mark the grave of a Levi, a descendant of the Biblical tribe that assisted the High Priests as Temple functionaries.

The raised hands shown on this marker indicate that the deceased was a Kohen, a descendant of Aaron and the High Priests who officiated in the ancient Temple. The severed willow, representing grief or sorrow, is also a traditional Victorian symbol of mourning.

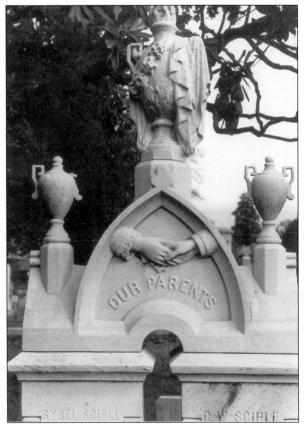

Clasped hands, like these found on the 1885 monument for Syble and George Sciple, show that "Our Parents" are joined in life and in death. A draped urn symbolizes death or sorrow.

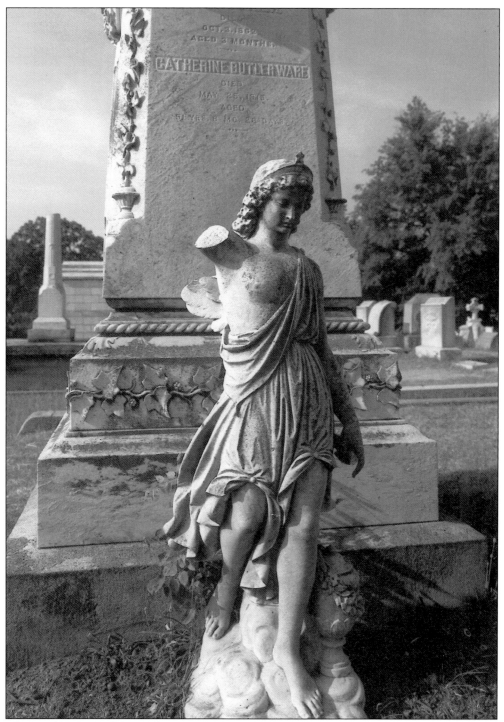

The angel in front of the Catherine Butterware monument is missing its right arm but remains a beautiful statue. Standing on a rock base to show a firm religious foundation, the missing hand was pointing up to lead the way to heaven. Ivy carved into the base of the monument symbolizes fidelity, abiding memory, and eternal friendship.

Traditional crosses top each of the Lynch markers. The headstone and rails outline the "bed" for the deceased who is "at rest" in the cemetery. Natives of County Meath, Ireland, the five Lynch brothers arrived in Atlanta in 1848. All were merchants except Patrick, who ran the Lynch's rock quarry.

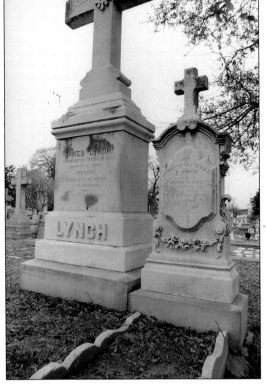

Twins Rosa Garnett and Virginia Taylor Roy were born on December 6, 1862. They both died of typhoid fever in 1878, one while in Richmond and the other in Atlanta. Their marker reads, "Twins in birth, twins in life, Twins in the grave, and twins in Heaven. May we be ready too."

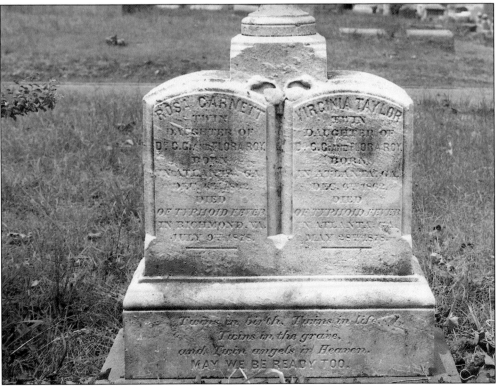

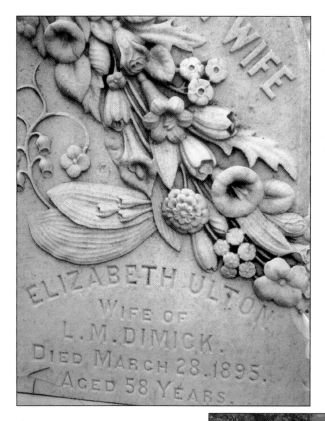

Elizabeth Ulton Dimick died on March 28, 1895 at age 58. This elaborate spray of flowers carved into her marker is very symbolic. Zinnias mean "I mourn your absence." Cala lilies are for sympathy. Bellflowers symbolize gratitude and acanthus are for the garden of heaven.

Joseph Dennis Wing died in 1912 at age two. His marker reads, "A little time on earth he spent, Till God for him his angel sent." Not only does his marker have a shawl, representing sorrow, but it also has a cradle carved into the stone. Many children died at young ages prior to our present-day advancements in modern medicine and immunology. Lambs were often used to top markers for children, representing the "Lamb of God."

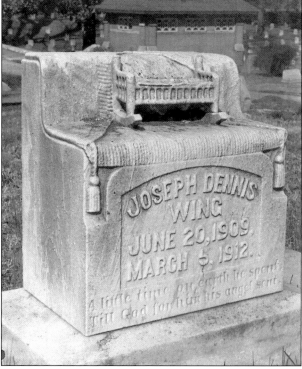

Broken tree trunks and columns traditionally represent lives cut short or dreams and goals gone unfulfilled or interrupted due to death. This tall trunk-style marker resembles the tall oak tree that stands beside it.

J.C. McLin's marker states, "A true, honest Christian man. A high and devoted mason, being the first man ever made a Sir Knight in Atlanta. A resident since 1849." The McLins were both born in Greenville, South Carolina, and died in Atlanta. Residents of Oakland were born in cities throughout America, as well as many countries, including Russia, Hungary, Germany, Ireland, and England.

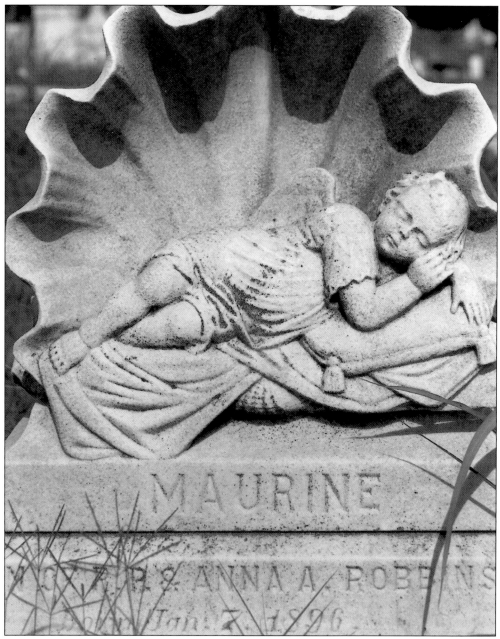

The Maurine marker shows a child asleep on a tasseled pillow, surrounded by a scalloped shell, which represents a pilgrim's journey and resurrection. This marker was available through the Sears catalog and several can be found at Oakland Cemetery. This marker reaffirms the cemetery as a "sleeping place."

Six

GARDENS AND LANDSCAPES

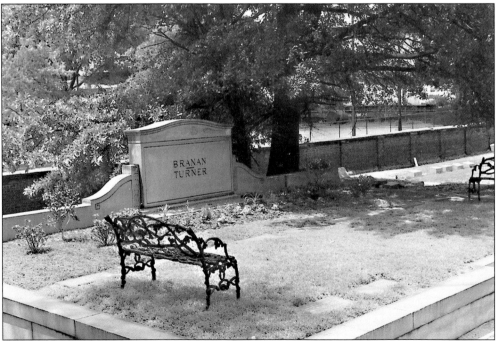

Historic benches such as these found on the Branan-Turner family lot are found throughout the cemetery. Shown are 19th-century cast-iron benches in a rustic style. Gothic- and fern-style benches are also commonly placed on family lots at Oakland.

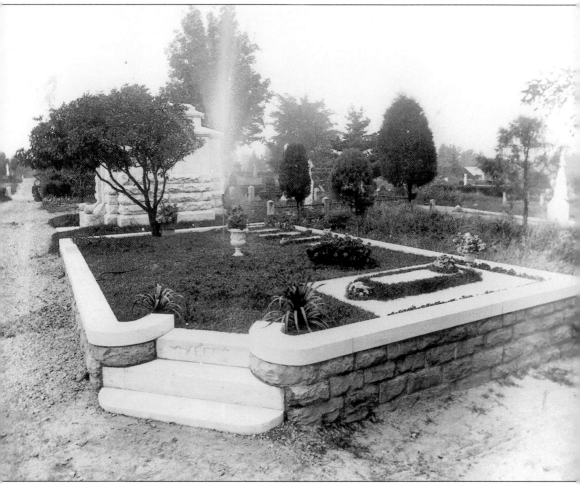

This 1890s photograph of the O'Keefe family lot shows how many families treated their cemetery plots as gardens. Notice the sprinkler spraying water in the rear of the lot. Dr. Daniel O'Keefe was a member of the city council from 1863 to 1870. He is remembered as Atlanta's "father of public education." Unfortunately, he died in 1871, a year before his dream came true. The public school system opened in 1872. (Courtesy of O'Keefe family.)

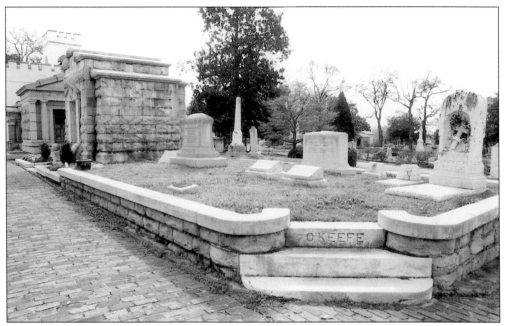

Note the differences between this current photograph and the historic photograph. The pathways surrounding the O'Keefe lot have been paved in brick. Plants and the sprinkler have been replaced by grass and additional markers. (Photo by Phillip Lovell, 2001.)

One of 50 original gas lamps installed in downtown Atlanta in 1855, this light still has shell markings from damage sustained during the Battle of Atlanta during the Civil War. Franklin M. Garrett donated the gas lamp to the cemetery in 1995.

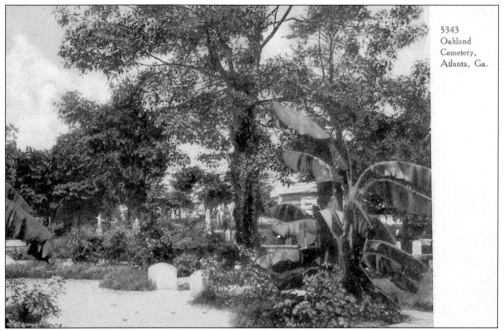

5343
Oakland
Cemetery,
Atlanta, Ga.

During the Victorian era, many families began to treat their lots at the cemetery as small gardens. As seen in this historic postcard, sand lots were not uncommon. It was fashionable to use exotic plants, such as the banana tree, on lots. Plants would be removed to Oakland's greenhouse during the winter.

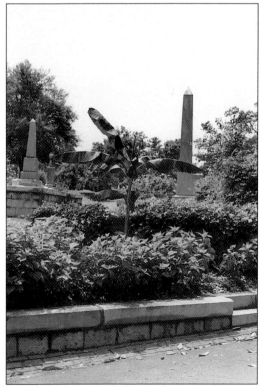

Pink hibiscus and a red banana plant were installed on the H.C. Johnson lot (Block 27, Lot 1) as an interpretation of the postcard shown above. An ivy garland graces the wall behind the banana plant, representing fidelity and abiding memory.

Constructed by the Marsh and Moore families, this gazebo (Block 61, Lots 3 and 4) provides a direct view of the Georgia State Capitol. William A. Moore, who died in 1891, was the senior partner of Moore, Marsh & Company, a prominent wholesale dry goods company. The Marsh Mausoleum can just be seen along the right edge of this photograph.

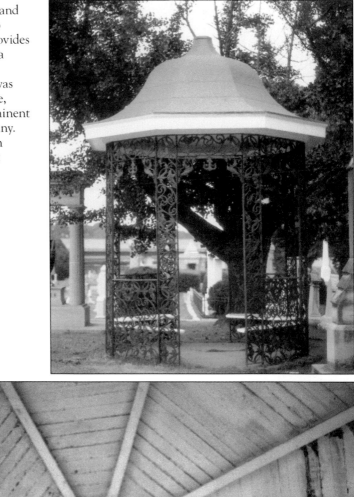

Pictured above is the coffered ceiling inside the gazebo. Photos of the Moore family's home at 20 Cone Street show a similar gazebo in their garden. It is believed that the gazebo was moved to its site in Oakland after the Moore's home was demolished in 1912.

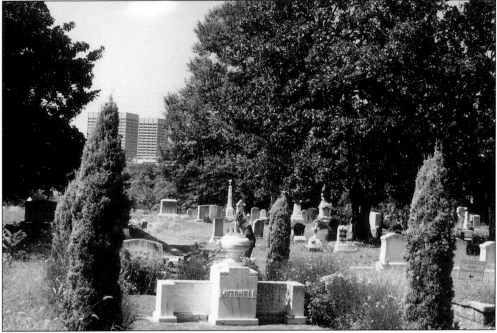

Four conifers anchor the Mitchell family lot (Block 22, Lot 1). Roses were reputedly Margaret Mitchell's favorite, so pink fairy roses and gaura, or whirling butterflies, surround the lot.

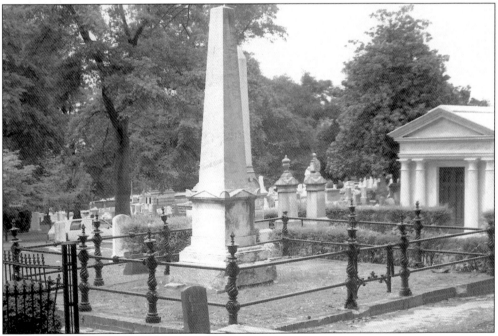

Many of the iron fences surrounding lots at Oakland were removed and melted down for munitions for both world wars. However, about two dozen fences remain, including this rather ornate fence surrounding the Mayor John Mims (1815–1856) plot. His monument reads "Faithful man, we command home to God." A traditional privet hedge encloses the Foreacre lot shown on the right.

Atlanta City Cemetery was renamed Oakland in 1872 because of the magnificent oak trees found throughout the cemetery. Varieties include white oaks, water oaks, and red oaks. Shown here is the damage that was caused after an oak tree outgrew its space.

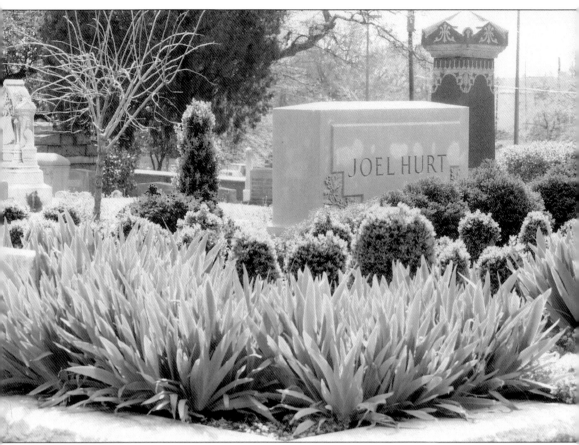

Joel Hurt was one of Atlanta's early entrepreneurs. With his business partner Samuel Inman, he developed the city's first suburb, Inman Park, in the 1880s. The Olmstead Brothers landscaping firm designed the neighborhood's park, Springvale. Replacing grass and azaleas, this landscape contains boxwood, mimosa, and iris germanica, commonly known as "cemetery whites."

Shown on the right is a working historic drinking fountain, c. 1890, located just west of the Bell Tower Building. It was produced by the Murdock Company of Cincinnati, Ohio—three of these octagonal-based fountains can be found on the grounds of Oakland. (Photo by Phillip Lovell, 2001.)

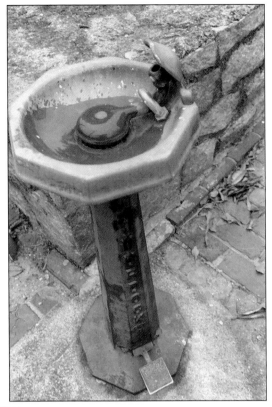

This is one of many cast-iron urns found throughout the cemetery. The egg-and-dart motif around the edge of the urn represents life and death, or the beginning and the end of life. The urn pictured here is most likely late 19th or early 20th century.

Oakland has several interpretive or theme gardens. Shown above is the Sawtell Rose Garden, developed in honor of Alice Greene Sawtell. Old roses with early introduction dates are featured in the garden, along with a carpet of golden thyme, also known as creeping thyme, and white iris or cemetery whites.

The Bonnell-Wadley Shade Garden is one of the few shady spots in Oakland. Plants used in this area include Carolina jasmine, oak leaf hydrangea, packisandra, epimedium, and dwarf mondo, in widespread use beginning in the 1940s. Packisandra was in use in the 1850s; its use in the South is questionable, but it provided ground cover to help fight erosion.

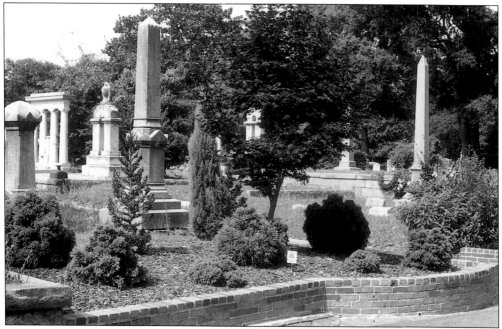

Shown here is the small Conifer Garden located just across from the Bell Tower Building. Developed in the 1990s, the lot features junipers and an assortment of small evergreens. Throughout the cemetery, conifers serve as living monuments and generally symbolize life and resurrection.

The Butterfly Garden is Oakland's only habitat garden and is enjoyed by thousands of butterflies, which symbolize life and death. Plants here include roses, asters, phlox, thyme, and verbena. The northern end of the garden features a small collection of sedums. These plantings help perpetuate the use of cemeteries as botanical gardens where people can learn about plants.

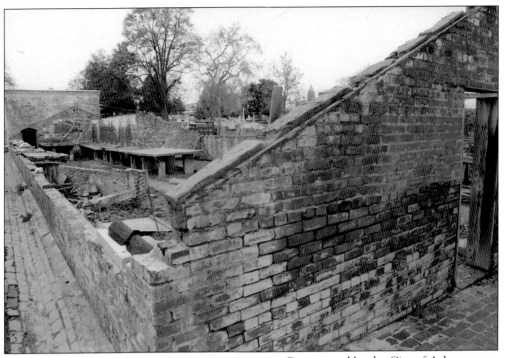

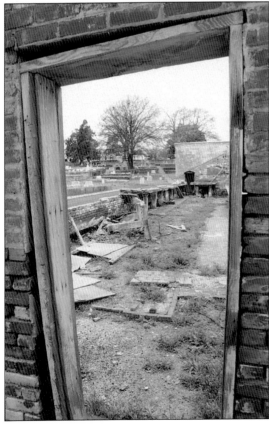

Constructed by the City of Atlanta, Oakland's greenhouse now lies in ruins, but plans have been made to rehabilitate the structure within the next two years. The view above shows that the brick sides and a few of the concrete worktables remain, but the glass ceiling panels were removed in the 1970s because many were broken and falling. (Photos by Phillip Lovell, 2001.)

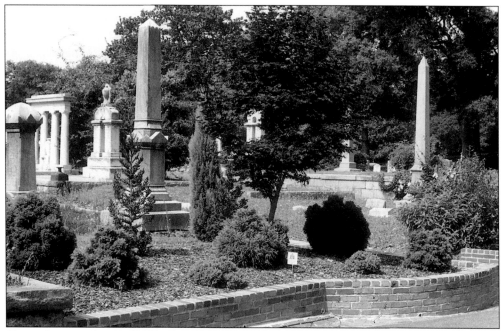

Shown here is the small Conifer Garden located just across from the Bell Tower Building. Developed in the 1990s, the lot features junipers and an assortment of small evergreens. Throughout the cemetery, conifers serve as living monuments and generally symbolize life and resurrection.

The Butterfly Garden is Oakland's only habitat garden and is enjoyed by thousands of butterflies, which symbolize life and death. Plants here include roses, asters, phlox, thyme, and verbena. The northern end of the garden features a small collection of sedums. These plantings help perpetuate the use of cemeteries as botanical gardens where people can learn about plants.

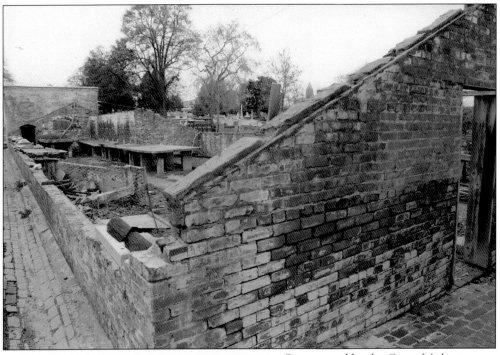

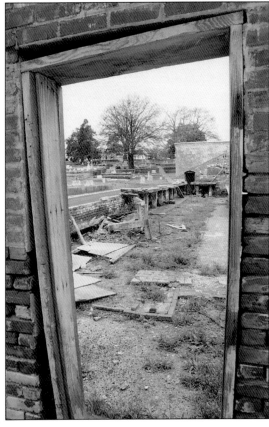

Constructed by the City of Atlanta, Oakland's greenhouse now lies in ruins, but plans have been made to rehabilitate the structure within the next two years. The view above shows that the brick sides and a few of the concrete worktables remain, but the glass ceiling panels were removed in the 1970s because many were broken and falling. (Photos by Phillip Lovell, 2001.)

The family plot of Judge Osborne Augustus Lochrane features a carpet of thrift or phlox in hot pink and grave blankets of ivy beginning at each pillow-shaped marker. The word cemetery means "sleeping place" and the pillows and blankets on this lot support that idea. (Photo by Phillip Lovell, 2001.)

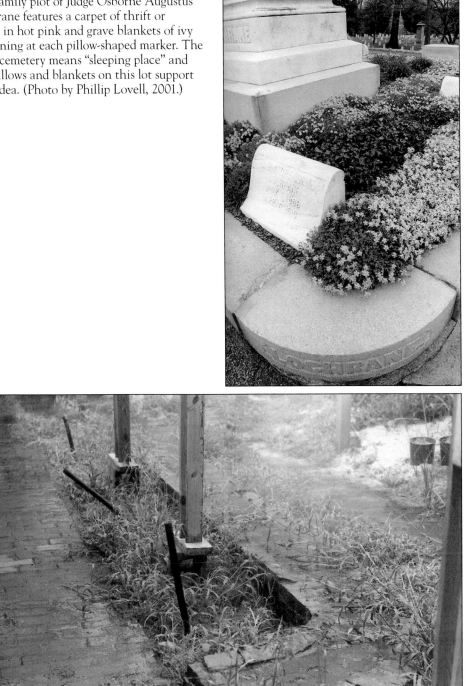

Pictured here is the original brick floor and underground heating system for Oakland's greenhouse, which was built in 1908 and now lies in ruins. During the zenith of gardening at Oakland in the early 1900s, the Cemetery Commission had to limit each family to one square yard of greenhouse space for the storage of their plants during winter.

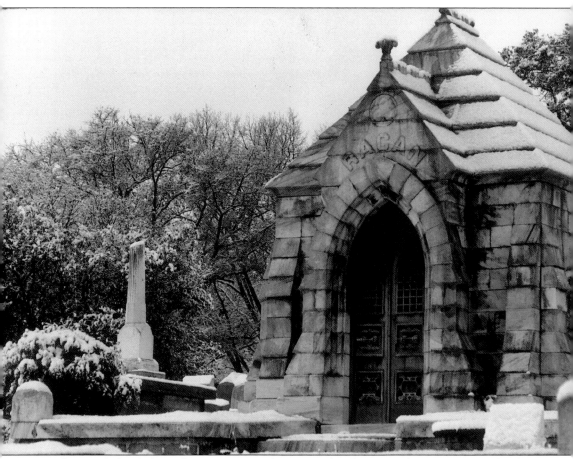

The view behind the Willis Ragan Mausoleum, completed in 1893, shows towering oaks above assorted shrubs and a cherry laurel. The planting next to the broken column is long gone, and a nandina is now in its place. Common shrubs found throughout the cemetery include boxwood, privet, hydrangea, flowering quince, and azaleas. (Photo by R. Shane Garner.)

INDEX